LITTLE BOOK OF

BALMAIN

T0018545

This book is a publication of Welbeck Non-Fiction Limited, part of Welbeck
Publishing Group Limited and has not been licensed, approved, sponsored,
or endorsed by any person or entity. Any trademark, company name, brand
name, registered name and logo are the property of their respected owners
and used in this book for reference and review purpose only.

Published in 2023 by Welbeck
An imprint of the Welbeck Publishing Group
Offices in: London - 20 Mortimer Street, London W1T 3JW &
Sydney - Level 17, 207 Kent St, Sydney NSW 2000 Australia
www.welbeckpublishing.com

Text © Karen Homer 2023
Design and layout © Welbeck Non-Fiction Limited 2023

A CIP catalogue for this book is available from the British Library.

ISBN 978-1-80279-673-5

Printed in China

10 9 8 7 6 5 4 3 2 1

LITTLE BOOK OF

BALMAIN

The story of the iconic fashion house

KAREN HOMER

WELBECK

CONTENTS

INTRODUCTION............................06

EARLY YEARS....................................12

THE HOUSE OF BALMAIN...............22

THE SOCIETY COUTURIER..............38

COSTUME DESIGN...........................54

A HOUSE REINVENTED....................68

OLIVIER ROUSTEING86

FRIENDS AND MUSES136

INDEX...156

CREDITS...160

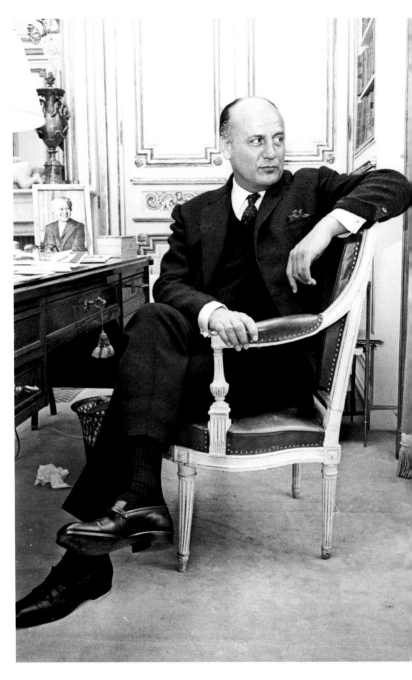

INTRODUCTION

"At the beginning, I could never believe what it could
be today, Balmain."
OLIVIER ROUSTEING 2019

Today, the luxury fashion brand Balmain is the go-to label
for high-octane glamour. Its name is beloved of celebrities,
including the Kardashian clan and Beyoncé, and it is worn
– often emblazoned on statement T-shirts – by fashion lovers
across the globe.

The House of Balmain was founded in 1945 by the Parisian
designer Pierre Balmain. A close friend and contemporary
of Christian Dior, Balmain helped develop the iconic New
Look hourglass silhouette that changed the world of fashion
during the late 1940s and 50s. His expertise was equal to
that of the legendary Dior and the two men almost set up in
business together. Balmain did not, however, go down in the
history of twentieth-century fashion in the same way as his
contemporaries, and it took until the beginning of the twenty-
first century, under the visionary designer Olivier Rousteing,
for the label to achieve the status that it enjoys today.

OPPOSITE Photographed in 1965, Pierre Balmain sits at his desk in the
grand Paris salon that he opened two decades earlier.

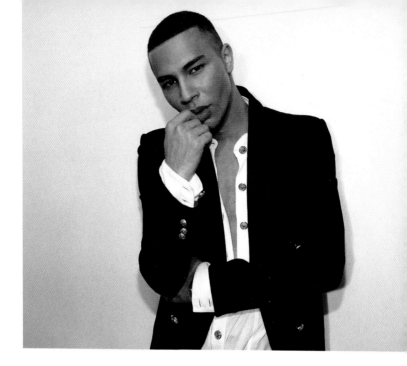

ABOVE Oliver Rousteing, the dynamic young designer whose social media savvy and celebrity contacts have transformed the house of Balmain since his arrival in 2011.

During the 1950s and 60s Pierre Balmain lost the reputation he had enjoyed in the elite world of couture when he began putting financial security before critical acclaim. He licensed multiple companies to sell products in his name, which quickly started to devalue the reputation of the Balmain brand despite its commercial success. Furthermore he became known as a celebrity dress designer who was happy to socialize with his clients rather than to keep the respectful distance and aloof profile that Paris expected from its couturiers. The final blow came in 1965, when Balmain was left off the *Women's Wear Daily* list of the "Big Six" of Parisian couture houses.

Nevertheless, Balmain was beloved of Hollywood stars and designed outfits worn both on- and off-screen by actresses including Elizabeth Taylor, Katharine Hepburn and Brigitte

LEFT This classic outfit from the 1950s captures Pierre Balmain at his design best. The buttoned grey wool dress features a bow detail at the waist and is complemented by a fur-lined shawl with matching fur hat and muff.

Bardot, for whom he created costumes for many of her early films. He even designed Audrey Hepburn's wedding dress for her marriage to Mel Ferrer in 1954 and was the first choice of European aristocracy when it came to wedding gowns. His longest royal patronage, which lasted two decades, came from Queen Sirikit of Thailand. For her he designed an extensive, highly glamorous, travelling wardrobe in 1960 to wear on a world tour with her husband, the king.

Pierre Balmain worked tirelessly until his death in 1982, but his name stagnated and today the stunning gowns and elegant tailored daywear of his early years have been all but forgotten. During the 1990s Italian designer Oscar de la Renta briefly lifted the flagging reputation of Balmain when he spent a decade as creative director but, although his couture was as exquisite as

OPPOSITE Like Pierre Balmain, Olivier Rousteing has created his own signature silhouette for a modern incarnation of the fashion house's elegant style. In this monochrome outfit from Spring/Summer 2013 he pairs an intricately detailed, structured raffia work top with Balmain's trademark wide shoulders, a pared down black leather miniskirt and ankle boots.

Balmain's own early designs, the world wanted something more modern. It was not until 2006, when Christophe Decarnin took charge, that the bling and glitz of the Balmain we recognize today started to emerge.

Decarnin transformed Balmain from an old-school, boring fashion house into a sexy, slightly trashy, high-end label, beloved of the fashion elite. Carine Roitfeld, at the time editor of *Paris Vogue,* took Decarnin under her wing and her extensive coverage of his signature look – sharp-shouldered leather jacket, distressed skinny jeans and T-shirts laden with Swarovski crystals – brought Balmain back into the limelight.

Until 2010, Decarnin reigned supreme, both celebrities and the wealthy flocking to buy his phenomenally expensive clothes. But inevitably, the high street seized on the trend and ripped off the Balmain look, damaging both its exclusivity and its profits. At the same time Decarnin started to struggle personally, and soon after he failed to turn up for his Autumn/Winter 2011 show the company announced his departure.

When Decarnin left there were fears that Balmain might sink as a fashion house but salvation came in the person of Olivier Rousteing, an unknown 24-year-old designer. In just over a decade Rousteing has elevated Balmain to become one of the world's most recognizable luxury brands. Sceptics who were uncertain about this handsome young man, with his model looks and the selfies he frequently posted on Instagram, were soon silenced.

In fact, Rousteing has become Balmain's greatest asset. He is a talented fashion designer with a gift for social media marketing, celebrity endorsements, and campaigns featuring a wide range of product collaborations. With his open and engaging personality, his willingness to address the challenges of the broken parts of the fashion system and his commitment to equality, Rousteing embodies what it is to be a diverse member of a global fashion community in a new millennium.

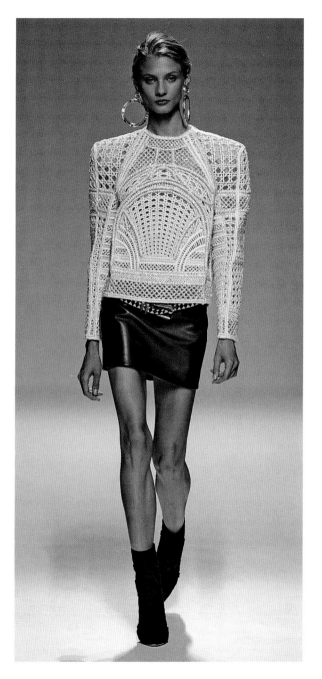

EARLY
YEARS

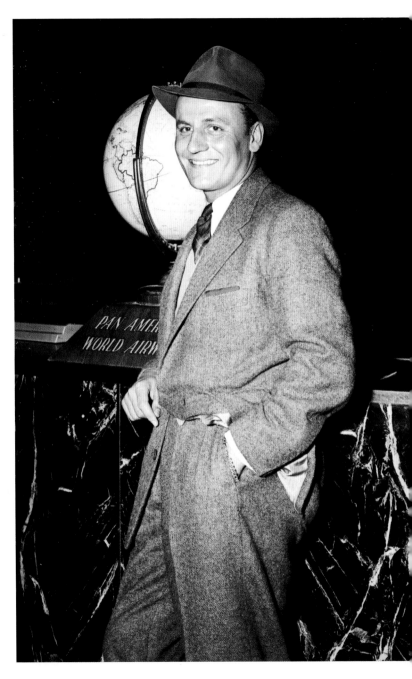

DETERMINED TO SUCCEED

Pierre Alexandre Claudius Balmain was born in May 1914, in the small French mountain village of St-Jean-de-Maurienne. He came from a family immersed in fashion.

His father had inherited a successful draper's business and his mother, Françoise, and her two sisters ran Galeries Parisiennes, a dress shop. As a young child Pierre spent hours in the shop, happy to be dressed up by his mother and aunts, and creating paper dolls complete with modish outfits. He was clearly destined for the world of fashion design.

When he was just seven years old, however, Balmain's charmed childhood came to an abrupt end. His father died suddenly, a shock compounded by the fact that the family were left virtually destitute: unbeknown to the rest of the family, the business was in severe trouble. The only item his father, a keen amateur actor, left to Pierre was a trunk full of old costumes. It was an unusual legacy, but a prescient one, providing a wealth of theatrical inspiration that proved pivotal to Balmain's future career.

OPPOSITE A young Pierre Balmain on his arrival in New York in 1945, the same year he was to debut his first haute couture collection in Paris.

At the age of 11 Balmain won a scholarship to an elite boarding school in Chambéry. There he learned the requisite skills of France's high society, including fencing, riding and dancing. These stood him in good stead in later years when he made his name as a couturier to the rich and famous, socializing with many of them.

For a brief period, Balmain studied architecture at the École des Beaux-Arts in Paris, and would later describe his clothes as representing the "architecture of movement", but he quickly decided to pursue fashion as a career. He had already worked freelance, contributing designs and illustrations to Robert Piguet, and he now approached several eminent designers for work. He was offered a position by Edward Molyneux whom Balmain – quoted by Colin McDowell in 2016 – described as "this elegant, aloof Englishman who held the fashion world in the palm of his hand during the 1930s."

In 1936 Balmain was called up for his obligatory military service. Like so many young men of his generation, he moved location constantly, at one point attached to an army regiment in the Alps, at other times travelling between the countryside and Paris. During this time he gained what could be called his first celebrity commission, from rather unusual clients: the American intellectual, novelist and playwright Gertrude Stein and her partner Alice B. Toklas.

The couple had befriended Balmain's mother, and Toklas asked Balmain to make her a warm coat and suit for the cold winters. Stein recalled to *Vogue* in 1945, on the occasion of Balmain's first couture collection, that the outfit was "as wonderful as any he was showing at his opening."

Stein continued: "Pierre used to go to and fro from Paris, and he brought us back a breath of our dear Paris and also darning cotton to darn our stockings and our linen, that was

OPPOSITE A black woollen afternoon dress with black satin basque by Lucien Lelong from the mid 1940s. Both Balmain and Dior designed for Lelong' fashion house during the Second World War and in 1945 Lelong showcased a collection that clear bore their trademar hourglass silhouette and longer length skirt.

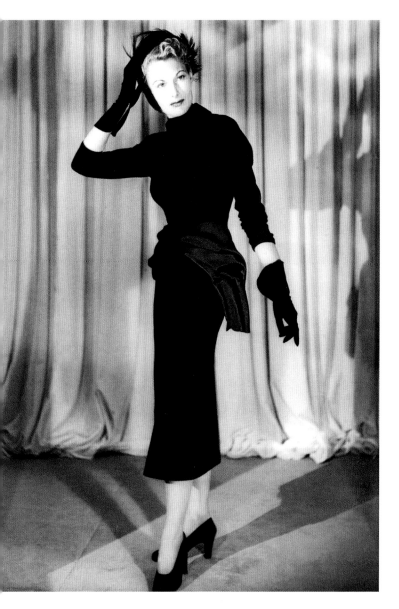

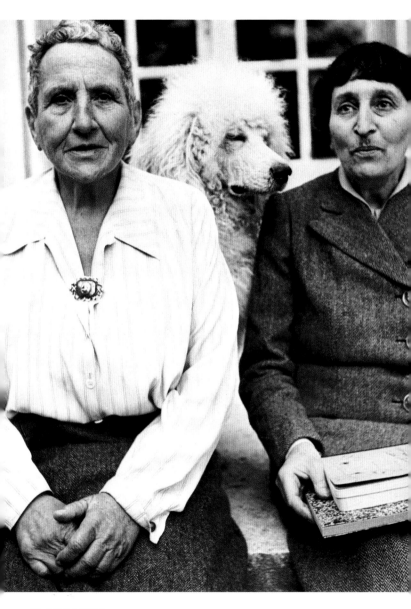

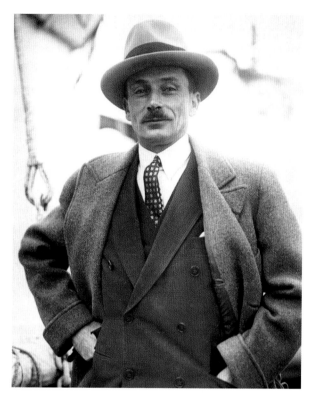

Pierre… At the opening, we were the only ones who had been clothed in all those long years in Pierre Balmain's clothes, we were proud of it… So pleased and proud."

Balmain completed four years of military service but was back in Paris in 1939, when he moved from Molyneux to Lucien Lelong. His contemporary at Lelong's fashion house was Christian Dior and the two men quickly befriended each other. The war years were a difficult time for French haute couture, and many establishments shut down or moved overseas.

OPPOSITE In 1945, after Christian Dior rejected his offer of going into partnership, Pierre Balmain struck out on his own. The designer is shown here pinning a dress on a model for one of his earliest collections.

Furthermore, the German occupiers wanted to move the cream of French haute couture en masse to Berlin. Lelong was the president of the Chambre Syndicale de la Haute Couture at the time, and now had to enter into negotiations. He persuasively argued that the plan was unworkable and haute couture remained in Paris, but inevitably many clients during these years were the wives of officers and other high-ranking Nazis. After the war ended, Lelong was tried for being a German collaborator but was acquitted. The judge ruled that he had cooperated with the Germans as little as possible and only in order to save French jobs and the cultural legacy of French couture.

Slowly the world of Paris couture began to recover and in 1945 Lelong sent a pared-down collection of outfits to be exhibited abroad, including a selection of dresses with nipped-in waists and longer-length skirts. There is no doubt that many of these designs, which were very successful, were the work of Balmain and Dior. The two men were very close at this point, so much so that Balmain asked Dior to go into business with him and set up their own couture house. Dior seriously considered the idea but eventually declined, leading to an acrimonious split between the two designers, from which their relationship never quite recovered. In 1945 Balmain struck out on his own and opened his own salon on rue François 1er.

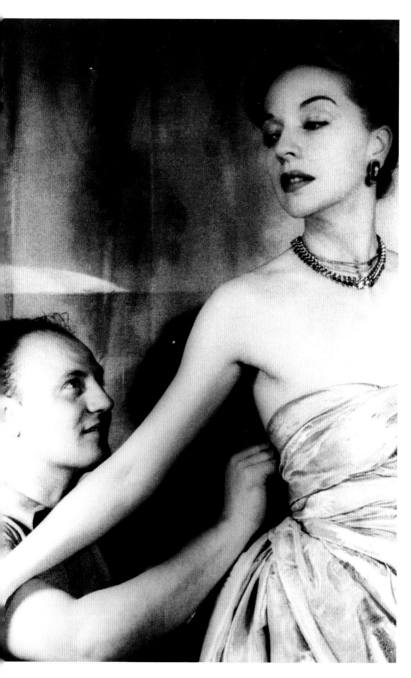

THE HOUSE OF BALMAIN

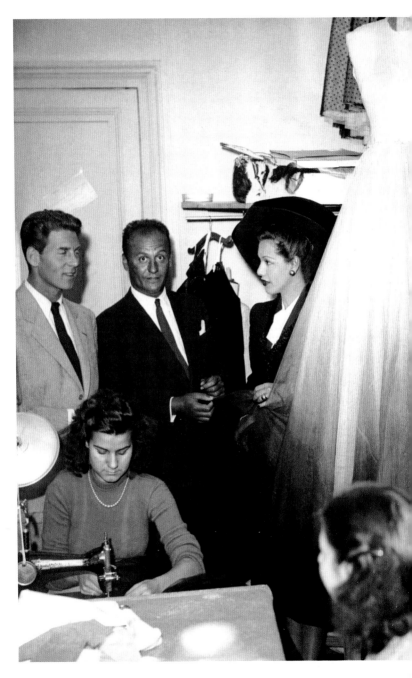

DEMOCRATIZING COUTURE

Pierre Balmain held his debut fashion show on October 12, 1945, at the grand house that would become his salon, on rue François 1er.

I n his 1964 autobiography, *My Years and Seasons*, he recalled the somewhat chaotic preparations for his first collection, which was pulled together by a skeleton staff, including his mother and aunts. Even Balmain found himself more hands on than usual, when "one evening I, who knew nothing of sewing machines, had to get down to padding the lining of a cape".

He continued: "We worked that time in what is probably the popular conception of the way fashion collections are prepared: frenziedly, with people fainting, and staff having to be plied with black coffee to keep them going… We were all very enthusiastic, very excited and inspired by a passionate belief that we were going to be a great success."

OPPOSITE Pierre Balmain in his atelier on rue François 1er, which he opened in 1945. Surrounded by seamstresses, he stands between the Dominican film star Maria Montez and her husband, while showing them the couture dress he has made for her.

RIGHT This outfit
from 1946 features a
simple, knee-length
candy-striped day
dress with a nipped-
in waist and flared
skirt, worn with a
matching tailored
coat with red-and-
white striped edging
and a single fastening
at the waist.

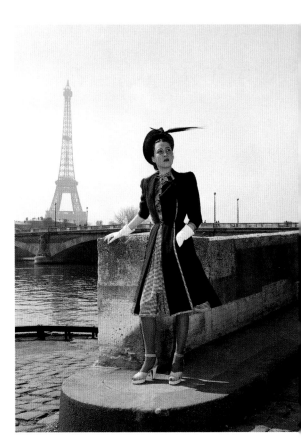

But more obstacles to his debut presented themselves. The first came when Balmain realized the famous couturier Madame Grès had moved her own show to the same date as his own. Generously, she changed it. The second was when the police and a bailiff turned up at the building he was using for his show. It seemed that the house had not officially been derequisitioned since the end of the war. Luckily, on witnessing Balmain's desperate state, the gendarmes departed.

The final hiccup was when Gertrude Stein and Alice B. Toklas's poodle, sitting with her owners in the front row, caught sight of a model walking down the catwalk with Balmain's own pet Airedale on a lead. Inevitably the dogs launched themselves at each other, but they were quickly separated and in retrospect Balmain decided that "the dog-fight had caused amusement and set a note of informality which probably helped the show get off to a good start".

The collection itself was a great success, capturing the post-war feeling of forgotten luxury combined with a fresh modern touch. There was an Eastern element in the form of woollen kimonos and the obligatory appearance of several decadent gowns, one in white brocade and heavily embroidered with silver and pearls, which the press seized upon as a triumph. Balmain concluded the show with a white and silver wedding dress that elicited a round of applause.

BELOW Balmain took his collections abroad very early in his career. This shot from a fashion show in Sydney in 1947 shows that he could even make a bicycling outfit look elegant.

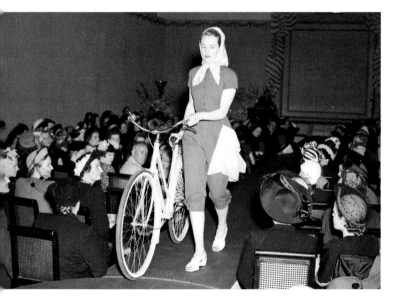

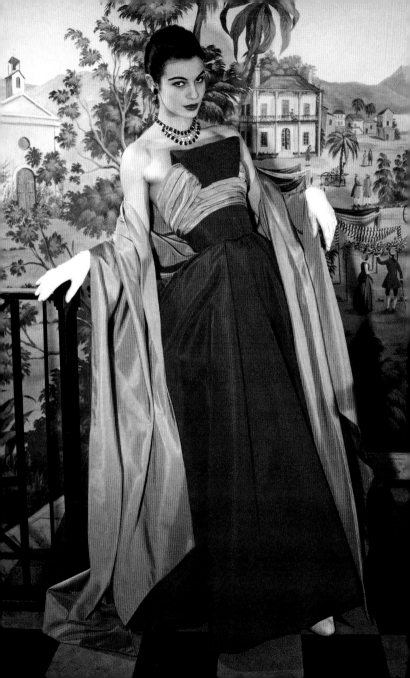

The critics were in agreement and the November 1945 issue of *Vogue* called the collection "gorgeous and wearable." Alice Toklas declared it a "New French Style", which, with hindsight, is ironic given how Dior would show a silhouette that would be dubbed the "New Look" and soon become much more famous and respected. But her words showed how Balmain was just as talented as his contemporary and had an equally clear vision of what women wanted from fashion in this new era:

"Suddenly there was the awakening to a new understanding of what *mode* really was: the embellishment and intensification of woman's form and charm."

It helped too that Cecil Beaton had been brought to Balmain's first show by Stein and Toklas. The irrepressible society photographer not only told all his friends and colleagues about the talented new designer but featured several of Balmain's gowns in the fashion pages of *Vogue*.

Looking back, it is interesting to compare Balmain to Dior at this point in time, before their careers were fully established and the designers took different paths. Inevitably, given that the two men had worked so closely together designing for Lucien Lelong, Balmain's silhouette had much in common with Dior's iconic New Look, first shown in 1947. In fact, the fashion historian Farid Chenoune called Balmain one of "the supreme practitioners of the New Look generation".

But while Balmain favoured the same hourglass silhouette as Dior, using corsetry and tailored peplum jackets to accentuate a tightly cinched waist, he preferred a longer mid-calf length for his skirts, and these were generally less full and more bell-shaped than Dior's, which were stiffened with layers of net petticoats and exaggeratedly flared.

Encouraged by the response to his first show, Balmain determined to find financial backing for his couture house. He sought outside investment and borrowed from his

OPPOSITE A typical example of Balmain's luxury evening wear from 1956. This dramatic red-and-pink silk gown has a stiffened red corseted bodice with a contrasting ruched pink detail. It is cinched around the model's tiny waist, flaring to a full skirt, and teamed with an elegantly draped pink silk stole.

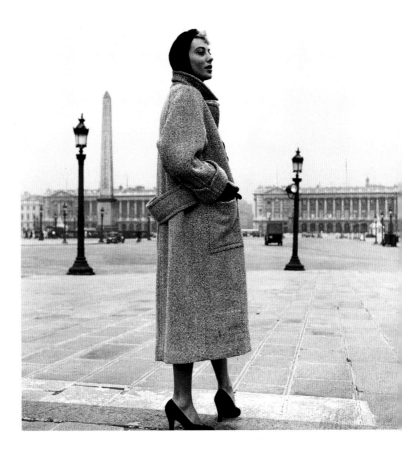

mother before he finally secured his future in a serendipitous arrangement with Barclays Bank in Paris, whose manager was a good friend of Molyneux. In fact, within six years, Balmain owned his company outright.

But the fact that Balmain sought financial security above critical acclaim dealt a severe blow to his reputation and he quickly became known as a society couturier, designing for aristocrats and royals as well as the most glamorous of

RIGHT This 1954 velvet sheath dress features an elaborate lace Bertha collar, complete with a central velvet bow. It is cinched in at the waist with a belt to accentuate the elegant silhouette.

OPPOSITE This belted travelling coat of heavy tweed exemplifies the meticulous attention Balmain gave to the construction of his clothes. Photographed in the Place de la Concorde in Paris in 1949, the coat features wide double cuffs, matching belt, and a collar that could be worn up or down.

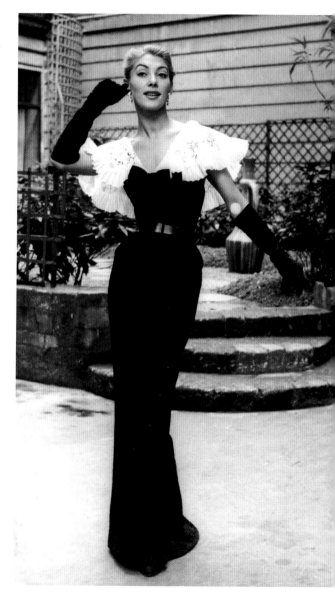

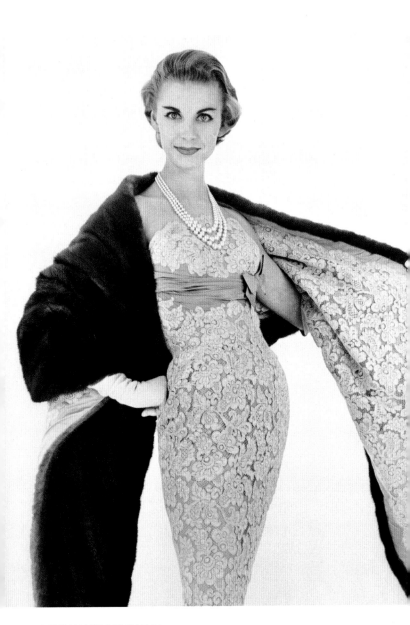

Hollywood's actresses. These associations, such as his long-term client Queen Sirikit of Thailand, did not win the approval of the snobbish world of Paris high fashion, where couturiers were expected to hold their clients at a respectful social distance.

Balmain's debut collection had been featured on the cover of American *Vogue* and he was happy to seek the potential for profit offered by the New World. He went on a promotional tour of Australia in 1947, and in 1949 opened a store in New York, quickly expanding to other parts of the United States. By the early 1950s Balmain had diversified into the lucrative world of ready-to-wear and had been embraced by America, winning the Neiman Marcus Fashion Award in 1955. His sophisticated and elegant ready-to-wear clothes became known as the "Jolie Madame" look – the name of the perfume released by the company in 1949, which became such a success that Balmain also used it for the name of his first haute couture collection of 1952.

It is unsurprising that Balmain found so much success abroad because his look epitomized Parisian chic, a style much sought-after coming from the fashion capital of the world. As his aesthetic evolved, the silhouette became more streamlined and the full bell-shaped skirt gave way to a slimmer look, still with a structured bodice and cinched at the waist but generally less fussy than some of Dior's designs. If anything, Balmain was more influenced by Balenciaga, adopting his cocoon-like capes and coats. Any embellishments were deliberately placed and never whimsical and the focus was always on purity of design and subtlety of detail, which suited his upper-crust clientele.

Throughout the 1950s Balmain created some of the most perfect examples of classic French couture, and fashion doyenne Diana Vreeland was quoted by *Vogue* saying: "A garment made by Pierre Balmain was the very quintessence of haute couture."

His brief training in architecture gave him an appreciation of structure and balance, which he transposed onto his comprehensive understanding of the interplay between different fabrics and textiles. Quoted by the Metropolitan Museum of Art, Balmain explained that a couturier "needs both the thick roughness of tweed and the evanescence of gauze or tulle."

Like his contemporaries, Balmain had technical skills that were finely honed. His evening gowns almost always had a corseted bodice but the skirt was often cut on the bias, or he cleverly draped lengths of fabric to flatter the female form perfectly. He also designed elegantly tailored suits for daywear

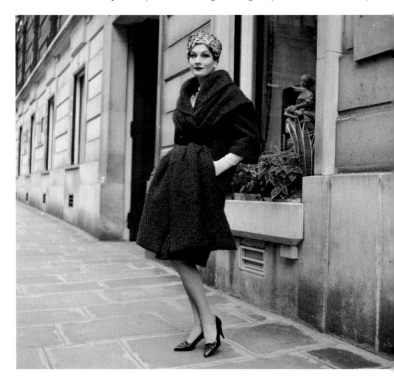

xpertly softening his outfits with fur stoles or draped capes.
Balmain's talents were certainly equal to that of big names
such as Dior or Givenchy, but in some ways he was more
conservative, happy to stick to the rules of correct dress. And,
unlike other iconic names from this period, Balmain did not
seek to break boundaries or push himself to experiment with
his designs. He knew his strengths and that he could provide
the glamorous gowns and elegant day clothes expected by his
clients. That was enough.

The final blow to Balmain's status as a top Parisian couturier
came in 1965. John Fairchild, owner of *Women's Wear Daily,*
listed the "Big Six" couture houses that had in his estimation

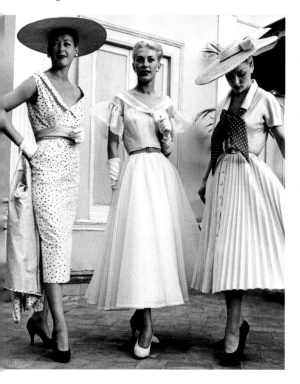

LEFT Balmain worked
on collaborations
from the beginning
of his career. This
trio of elegant day
dresses, exemplifying
the "Jolie Madame"
look for which he
became renowned,
was created by the
designer to advertise
Vittel, a French brand
of bottled water,
around 1950.

"put a stamp on fashion", and Balmain was not included. This despite a high profile, including his appointment as a chevalier de la Légion d'honneur in 1962, his commercial success and his obvious devotion to the exquisite workmanship of haute couture.

As the years went by, Balmain continued to design the timeless classics with which he had made his name, although as fashions evolved through the decades he didn't always change with them. The bigger problem with the fashion label, however, was that Balmain had allowed his name to become over-licensed and the sheer number of products available worldwide began to devalue the brand.

RIGHT During the 1960s Balmain very much kept to the traditional aesthetic that had made his name while gently adapting to changing fashions by using subtle detailing. This pale blue wool coat, with a tiny "shirtband" collar, from his Spring/ Summer 1962 collection is cut in a straight line but uses large, flapped pockets to draw attention to where a woman's natural waistline falls, thus alluding to a feminine shape.

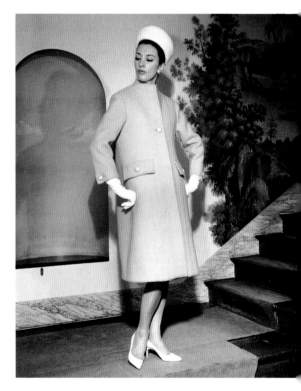

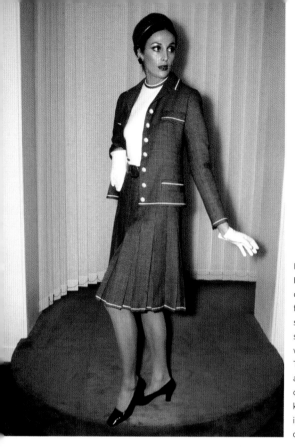

LEFT By the 1970s, Pierre Balmain had dropped off the fashion world's radar somewhat, but he was still creating classic, well-designed clothes. This wool day suit, with a tiny blue-and-white check, has a pleated knee-length skirt and is finished with accents of red.

rfume was perhaps the one exception and Balmain enjoyed ccess with his fragrances, from the launch of his first scent, ysées 64–83, in 1946. Vent Vert, released in 1947, became e of the most popular perfumes of the late 1940s and early s, and Jolie Madame, created by the "nose" Germaine ellier, has been successfully reformulated several times. He en launched Revlon's first perfume, Miss Balmain, in 1966.

Balmain eventually sold his company in 1970, although he ntinued as creative director until his death in 1982.

THE
SOCIETY
COUTURIER

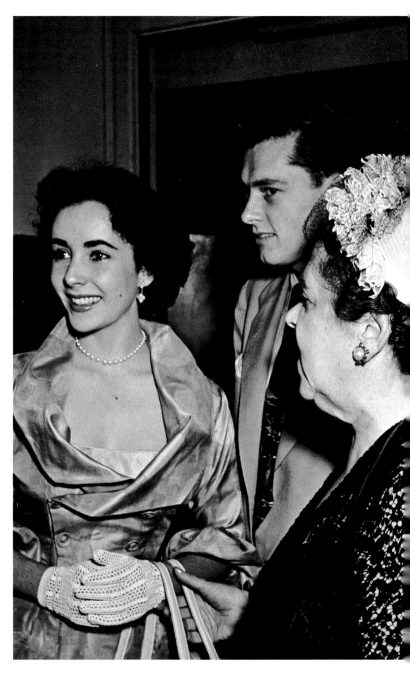

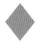

DRESSING THE RICH AND FAMOUS

From the early days of his career, Pierre Balmain was known as a society couturier. He had befriended the avant-garde writer Gertrude Stein during the war years – he called Stein and her partner Alice B. Toklas "his American mothers" – and she had positively reviewed his 1945 debut for *Vogue* magazine.

Also in the front row were English society photographer and diarist Cecil Beaton and French artist and illustrator Christian Bérard, described by Colin McDowell for the *Business of Fashion* as "two of international fashion's greatest gossips". Both men were very happy to spread the word about Balmain's arrival on the scene and orders arrived immediately, including from the Duchess of Windsor, a notable style maven.

The atmosphere at Balmain's salon was extremely welcoming, far more so than the salons of some of his contemporaries. His

OPPOSITE An 18-year-old Elizabeth Taylor on her honeymoon in Paris to first husband Conrad "Nicky" Hilton in 1950. The beautiful young actress, whose first marriage lasted just eight months, is wearing an outfit by Balmain comprised of a printed silk dress, with boned corset and spaghetti straps, and a matching double-breasted evening jacket. The tailored jacket features a draped, scoop neckline, three-quarter-length puff sleeves and a double-breasted button closure at the waist.

atelier's longtime directrice, Ginette Spanier, who ran the House of Balmain from its inception until 1976, described his warmth in her 1959 autobiography *It isn't All Mink*:

"He is an extraordinary personality. Bouncy as a countryman, he is the exact opposite of the conventional idea of a couturier… He has a wonderful memory. He remembers every dress he has ever made, with its name and number, and the customer to whom it has been sold. His whole existence is the couture… He loves dancing… He loves publicity."

It was inevitable that a designer of Balmain's calibre would attract the celebrity actresses of Hollywood's golden era, and the unique hospitality his salon offered certainly helped.

RIGHT Pierre Balmain designed outfits for actress Katharine Hepburn for her private life as well as her stage and screen roles. This relaxed shot is from 1950.

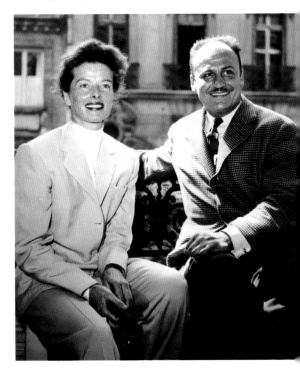

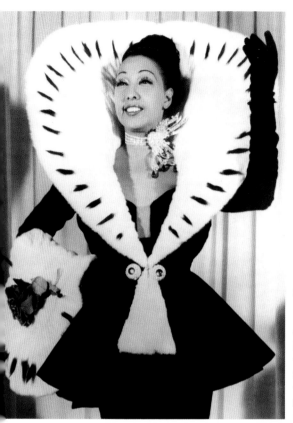

LEFT Legendary French performer Josephine Baker was one of Balmain's earliest clients. She is pictured here wearing a black velvet dress with a matching ermine-trimmed cape, which she wore to perform in New York in 1951.

inette Spanier also recalled in her memoir how clients such Marlene Dietrich would be invited to her flat for a home-oked meal.

Balmain's greatest appeal, however, lay in his masterful signs. While his slim tailored day suits were consistently pular, he became best known for his lavish evening gowns, ade with the most sumptuous fabrics and covered in arkling beads and embroidered sequins. Accessorized with

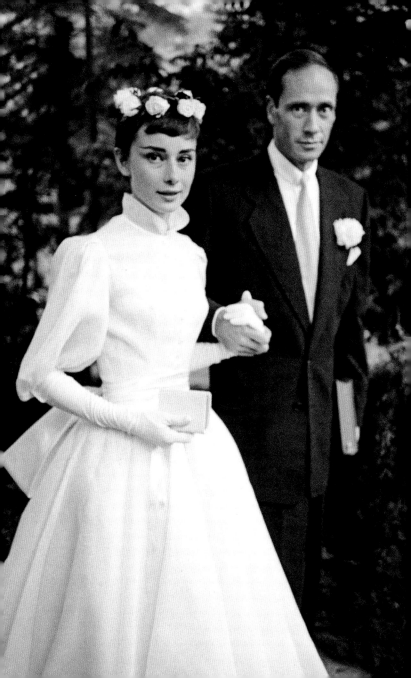

RIGHT Balmain had a close working relationship with Brigitte Bardot, designing her film costumes during the 1950s and 1960s. The actress also chose his gowns for formal events, and is seen here in a white satin gown, heavily embroidered with sequins, for her presentation to the Queen at the Royal Film Performance in October 1956.

OPPOSITE When actress and style icon Audrey Hepburn married Mel Ferrer in 1954, she chose Pierre Balmain to design her wedding gown. The white silk tea-length dress has a high stand collar, three-quarter length gown sleeves and three pearl buttons to the waist. Its cinched waist, emphasized by a flared skirt and wide satin belt that finished in a bow at the back, gives the gown a classic 1950s' silhouette which flattered Hepburn's slight physique.

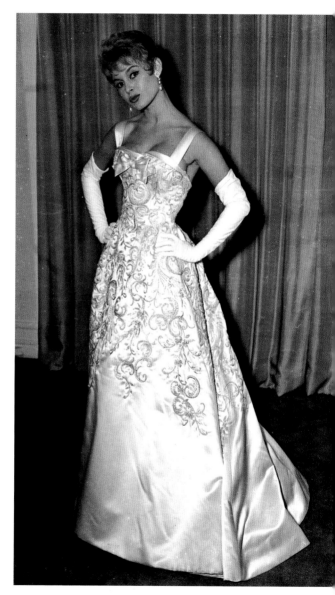

a fur cape or feather trim, these were elegant without being overly modish, as Balmain prioritized timeless glamour over the latest fashionable cut. This meant his dresses were a true investment that could be worn for years to come.

A roll call of stars, including Elizabeth Taylor, Brigitte Bardot, Katharine Hepburn, Ingrid Bergman, Vivien Leigh and Sophia Loren, flocked to buy what were regarded as the most beautiful dresses in Paris. Even the gamine style icon Audrey Hepburn was a fan, despite her close friendship and working relationship with Givenchy. In fact she commissioned Balmain to design her wedding dress for her marriage to Mel Ferrer in 1954.

As *Le Monde* observed in 1958:

"The famous clients of Pierre Balmain are quite numerous. We know that Lili Palmer wears nothing but his light wools for both day and night, while Ingrid Bergman is not so constrained and feels free to wear whichever of his designs tempt her… Finally, Brigitte Bardot has attracted a lot of attention with the velvet dress, worn under a matching coat that Pierre Balmain created specially for her."

The sophistication of Balmain's designs meant that they were of particular appeal to royals and the upper classes, as well as others on the ambassadorial circuit who needed to carefully calibrate their image. One of his most elaborately appliquéd gowns, shown as part of the Victoria and Albert Museum's The Golden Age of Couture exhibition, featured a floral print and the classic 1950s silhouette of corseted bodice and flared skirt. It was worn by Lady Diana Cooper, the socialite and notable beauty, at a state dinner for Queen Elizabeth and Prince Philip in April 1957.

Wedding dresses were another area of couture in which Balmain excelled, with many European royals, including Princess Irene of the Netherlands, choosing to be married

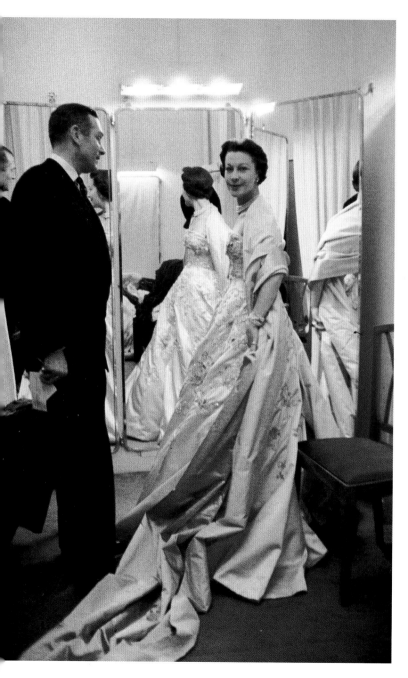

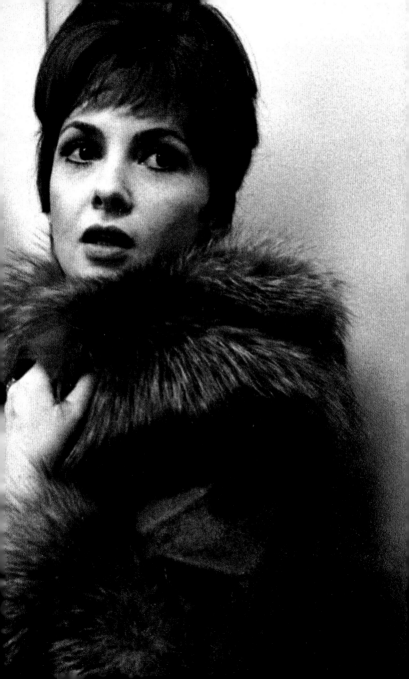

in his gowns. Other royal clients included Queen Fabiola of Belgium, Queen Basna of Jordan and the Princesses Maria-Teresa and Margaretha of Luxembourg.

But the royal with whom Balmain became most associated was Queen Sirikit of Thailand. The queen, whose mother was an actress and father a Thai ambassador to Britain, had spent her childhood travelling between Thailand, England, Denmark and France and had a keen appreciation of the need to project an image that balanced Asian and European cultures. She was a young girl when Balmain first met her in 1947, while visiting Bangkok on his way back from Australia. In 1960, now Queen, she turned to the Parisian designer to commission a wardrobe for a grand world tour with her husband, visiting 15 countries over six months.

Balmain embraced the challenge and travelled to Thailand to spend several weeks designing the many outfits that the queen needed to appear appropriately dressed for every occasion. He also had to consider the practical implications

BELOW Queen Sirikit of Thailand in Bangkok in 1965. The queen, who used Balmain as her couturier for two decades, is wearing a dress woven with 24-carat thread and embellished with crystals. For all the queen's outfits Balmain sensitively combined the chic elegance of Parisian fashion with traditional Thai styles.

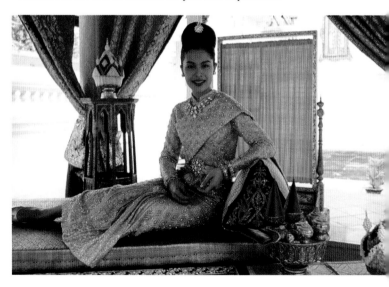

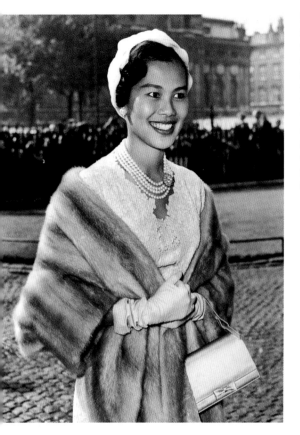

the tour, such as travel during a range of seasons, and was ven responsibility for all the accessories Queen Sirikit would ed. To design a cohesive look, Balmain was given access the fabulous royal jewellery collection so that he could eate outfits to complement the jewels the queen would wear, ported by the *New York Daily News* at the time as including iamonds, rubies, emeralds, sapphires, amethysts, topazes, cons, garnets, and opals".

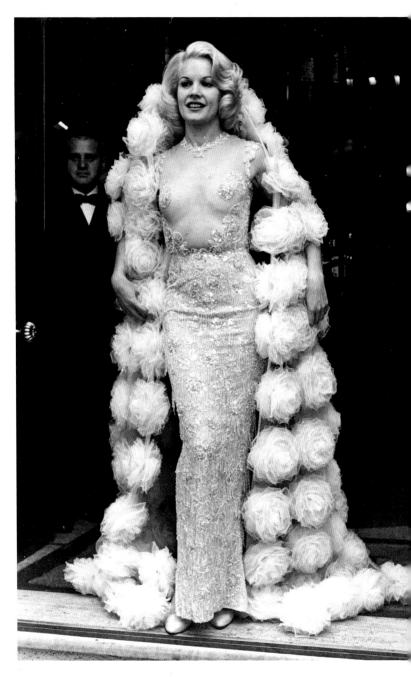

The most important thing Balmain needed to do was blend traditional Thai styles with Western fashions. To this end, bolts of Thai silk were sent to Balmain's Paris atelier and a fit model with virtually the same measurements as Queen Sirikit was found. When it was complete the wardrobe contained approximately 150 pieces of clothing, including day suits, cocktail wear and grand evening gowns, along with fur wraps, coats, hats, and even coordinating raincoats and umbrellas. Sensitive to the importance of incorporating traditional touches, Balmain built on his signature silhouette to include jackets with small ties at the front and back and lavish bows inspired by obi sashes. Large embroidered silk flowers were added to Balmain's bodices and lapels, and he draped fabric cleverly around the hips and waist to emulate traditional Thai dress.

BELOW Princess Margaret sitting in the front row of a charity fashion show given in London by the House of Balmain in 1966. She was a big fan of Paris couture houses and patronized several, including Balmain.

OPPOSITE Actress Carroll Baker pictured wearing a shockingly revealing dress by Balmain to the premier of her film *The Carpetbaggers* in London in 1964. The sheath gown, heavily embellished with crystal beading had a sheer top, Baker's nipples barely covered by cleverly placed embroidery. The glamorous silk chiffon long cape she wears over it is adorned by large roses.

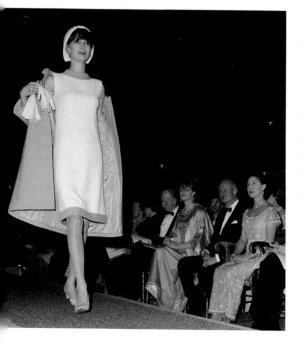

COSTUME
DESIGN

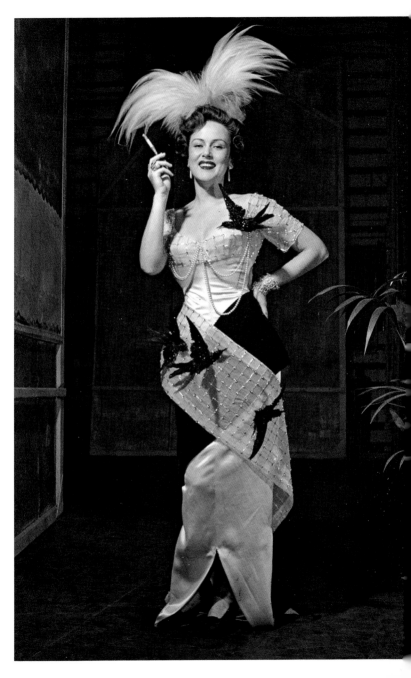

A FLAIR FOR
THE THEATRICAL

Balmain's father left him one thing when he died, a
trunk full of theatrical costumes from his days as a keen
amateur performer. The legacy obviously had an impact
on the young designer, who turned his hand from the very
beginning of his career to designing costumes.

Many famous actresses and entertainers were already loyal
clients of the couturier, choosing Balmain's gowns for
premieres and parties, so it was an obvious next step for him to
design for their stage and screen performances. For example,
the French dancer and actress Josephine Baker, who frequently
wore Balmain off duty, chose him to design many of her most
iconic stage outfits, including a stunning halterneck gold
lamé gown which she wore to perform in New York City in
1951. Balmain subsequently designed Baker's wardrobe for her
eponymous revue in 1964.

OPPOSITE Balmain started designing for the stage and screen during
the 1940s. This flamboyant monochrome silk creation has beaded
embellishments and draped pearls as well as exotic sequinned birds and an
extravagant osprey feather headpiece. It was worn by French actress Nadia
Grey in a 1949 production in Paris of Tristan Barnard's play *Le Petit Café*.

Balmain's clothes started being featured in French films as early as the late 1940s. Marlene Dietrich selected some of his outfits for her 1951 film *No Highway in the Sky*, and one of his first clients to request he design a dress for a stage role was Katharine Hepburn, who was to appear as Epifania in *The Millionairess*, showing in London's West End in 1952.

Hepburn and Balmain were already friends and he was happy to help. The most dramatic of the actress's costumes by Balmain was a full-length silk tulle ballgown, heavily embellished with embroidery and sequins resembling flowers and fleur-de-lis. A matching long cape gave the outfit a regal look and her gloves were embroidered to match the dress.

When Sophia Loren took on the role of Epifania in the screen version of *The Millionairess* in 1960, Balmain was again called upon to design the character's costumes. This time he created a wardrobe of extravagant outfits, befitting the persona of the richest woman in the world, and Sophia Loren's Italian glamour suited them perfectly. The most iconic was a sleeveles pink silk gown with a signature Balmain bow detail across the bust with a matching wrap and hat. Loren famously stripped off the gown in the film to reveal black lace underwear. The dress sold for £10,000 at auction in 2016.

A second dress from *The Millionairess*, which came up for auction in 2022, was a full-skirted knee-length gown with a fitted bodice and plunging neckline made from cream tulle. In typical Balmain style, it was trimmed with lace and embellishe with costume pearls and embroidered Swarovski crystals.

With Brigitte Bardot, Balmain had a designer-muse type relationship, not dissimilar to that of Givenchy and Audrey Hepburn, although not as long-lived. As well as creating outfit for the actress's off-screen socializing, Balmain designed many of her early costumes.

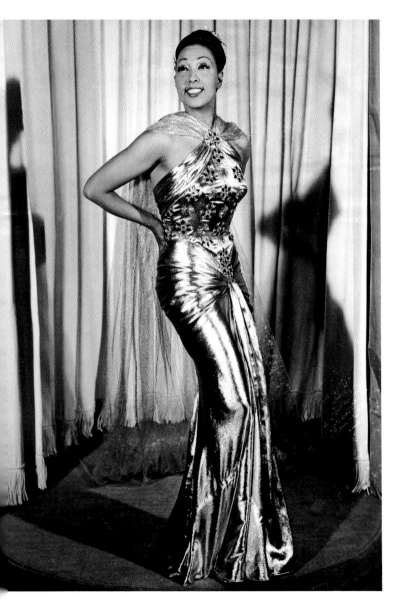

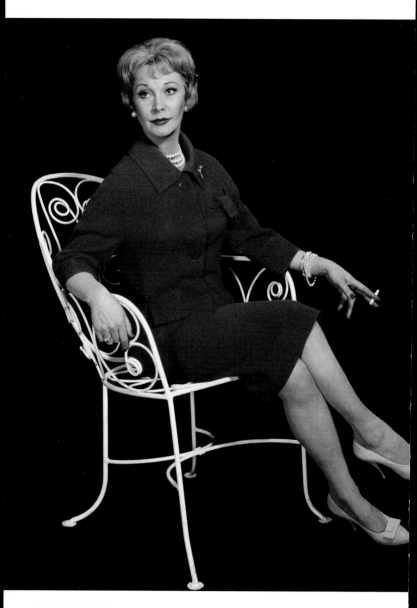

RIGHT When Vivien
Leigh starred in
The Deep Blue Sea
in 1955, Balmain
created this
glamorous oyster-
coloured, halterneck
gown. It has a heart-
shaped crossover
bodice bearing a
beaded floral motif,
an arrow belt detail
and full skirt.

OPPOSITE Balmain
designed for Vivien
Leigh several times,
including a more
mature, tailored
red wool suit which
perfectly suited the
actress's character
in the 1961 romantic
drama The Roman
Spring of Mrs.
Stone, based on the
Tennessee Williams
novel.

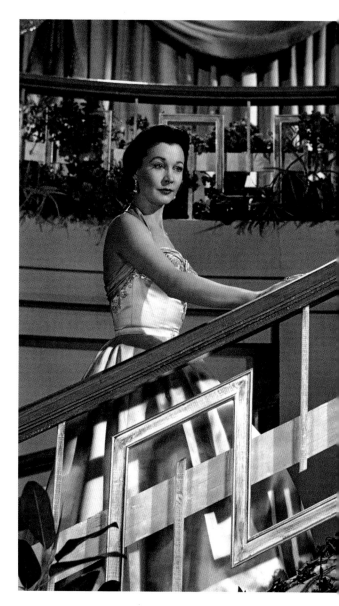

BELOW Balmain created this delicate white chiffon négligée as one of the outfits for Brigitte Bardot to wear when she played a haute couture model in the 1956 film *Her Bridal Night*.

OPPOSITE During the 1950s and early 60s, Balmain designed many figure-hugging outfits for Brigitte Bardot. In this shot from 1956, the blonde bombshell is wearing a skintight embroidered satin dress, which gave her some trouble when she tried to curtsey.

Bardot's 1956 film, *Her Bridal Night*, told the story of Chouchou, a country girl who is discovered by a fashion magazine and transformed into a top model. The costumes needed to reflect the most exquisite and fashionable haute couture for which Paris was renowned – and Balmain obliged One gown, in classic 1950s style, had a ruched, sculptured bodice and a delicate flared skirt, stiffened by net petticoats and seemingly covered in petals. The star outfit was, of course the bridal gown itself, which featured a high-necked heavily appliquéd lace bodice that accentuated Bardot's narrow waist and skimmed over her hips to explode in a bouffant skirt mad from layers of tulle, finishing in a train.

Also in 1956, Balmain designed the outfits for Bardot's filr *And God Created Woman*, arguably the picture which made her a star. Despite the film's reputation for nudity – Bardot plays Juliette Hardy, an 18-year-old happy to lounge around barely clothed – Balmain was required to make plenty of clothes for the actress. These were more casual outfits than for previous films, including day dresses and jumpsuits, but

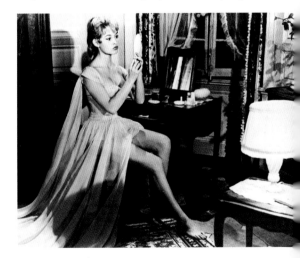

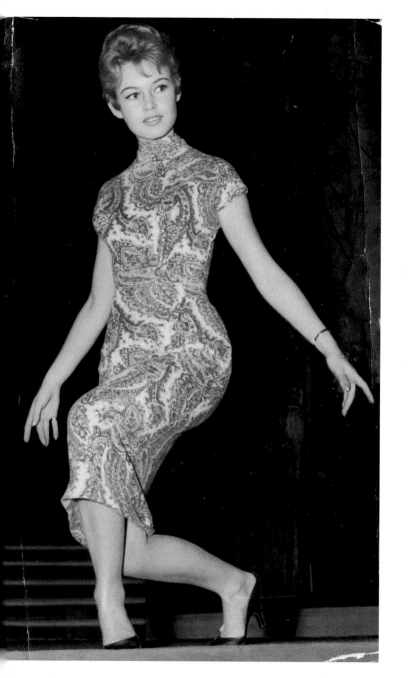

ere nevertheless perfectly pitched to Bardot's provocative character, being innocent at first glance but then moving sensually with her body.

La Parisienne, Bardot's 1957 comedy, is another film where Balmain's costumes stand out. Her wardrobe included full-skirted corseted dresses, a stunning fitted red satin evening gown, and other, slimmer outfits such as a pink wool cardigan and grey tailored skirt, the tight belt and half-unbuttoned knit accentuating Bardot's curves. Balmain also designed outfits for Bardot's 1958 film *In Case of Adversity* (released as *Love is My Profession* in the US).

Balmain's most memorable costume design work came during the 1950s and 60s, an era that suited his trademark aesthetic of sophisticated glamour. He designed outfits for Vivien Leigh to wear in several of her films, including a glamorous ball gown for *The Deep Blue Sea* in 1955, and a series of tailored separates for the actress to wear in *The Roman Spring of Mrs. Stone* in 1961. He also created an effortlessly chic French wardrobe for Jane Fonda's character in *The Love Cage* (*Joy House* as it was named in the US) in 1964.

Another film where the costumes played an important part, and one in which Balmain was able to indulge his love of glitz, was *Two Weeks in Another Town* (1962), starring Cyd Charisse. Balmain used a fashionably bold colour palette of yellow and green for daywear, including a stunning tailored yellow wool crêpe dress with a draped neckline finishing in a trailing scarf with a matching head wrap and pearls. Charisse also wore a knockout glittering black full-length fitted evening gown, with oversized shoulder embellishments made from cockerel feathers.

Balmain continued to design for stage and screen throughout his career, receiving costume credits for over 50 films and accolades for stage design, including a nomination for a Tony for Best Costume Design for *Happy New Year* in 1980.

OPPOSITE Balmain also designed the costumes for Bardot's 1957 comedy *La Parisienne*. This simple jersey shift fitted the character and flattered the actress's curvaceous figure.

It is interesting to compare Pierre Balmain with current creative director Olivier Rousteing, who has very much revived the fashion house's tradition of designing for stage and screen. In recent years he has worked on projects as diverse as The Paris Opera, Beyoncé's costumes for the On the Run II tour and a collaborative collection with Netflix's Western *The Harder They Fall*.

LEFT Jane Fonda required a chic French wardrobe for the film *The Love Cage* and Balmain provided outfits such as this neat woollen sweater matched with a tweed knee-length skirt.

OPPOSITE Cyd Charisse starred in *Two Weeks in Another Town* in 1962, for which Balmain designed some stunning outfits, including this sensual, lemon yellow full-length chiffon dress with crossover bodice and satin belt.

A HOUSE
REINVENTED

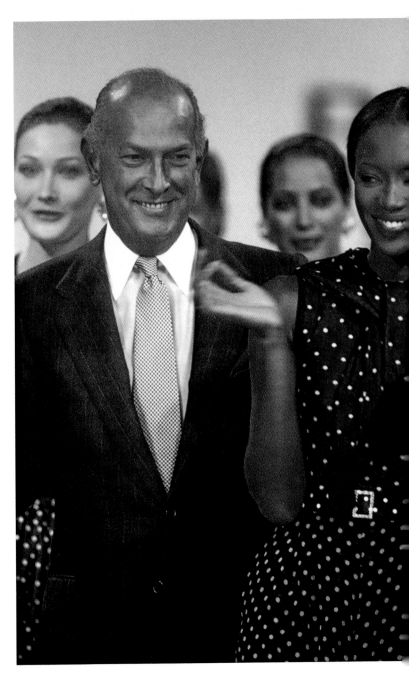

FIGHTING FOR SURVIVAL

When Pierre Balmain died in June 1982, aged 68, his name was no longer spoken alongside the other legends of Parisian haute couture. But despite fading from the world he had once commanded, Balmain remained a respected and hardworking designer to the end. He even sketched his last collection on his deathbed.

Balmain was immediately succeeded by Erik Mortensen, his one-time lover who had worked for the house since 1951 and whom *Vogue* described as his "right hand". Mortensen continued in the same vein as Balmain himself, but despite winning two awards for his haute couture collections in the 1980s, he didn't set the fashion world on fire and left in 1990. His immediate successor, Hervé Pierre, lasted just 18 months, subsequently becoming known as a personal stylist renowned for power dressing political wives, including Hillary Clinton and Melania Trump.

OPPOSITE Dominican designer Oscar de La Renta took over as creative director of Balmain in 1993 and stayed for almost a decade. He is pictured here taking applause at the end of his Autumn/Winter 1994 show, surrounded by supermodels Carla Bruni, Naomi Campbell and Helena Christensen, who are all wearing polka dot outfits typical of the decade.

In 1993, in an attempt to restore the fashion house to its former glory, Balmain chose a famous name to be its next creative director: Oscar de la Renta.

De la Renta promised, in a statement released by the label at the time, to bring "new life and momentum" to the brand – and in some ways he succeeded. He certainly attracted, in the words of *Women's Wear Daily* in 2002, "new credibility and a long list of boldface names". His front row regularly saw the likes of high-profile socialites including Marie-Chantal, Crown Princess of Greece, and Alexandra von Fürstenberg as well as more populist names such as American romance novelist Danielle Steel.

But despite de la Renta's high personal profile, and his own successful eponymous label, the designs were essentially just updated versions of the old classics. Nevertheless, de la Renta was a highly skilled designer whose aesthetic revolved around an elegant and timeless silhouette, a style that fitted exceptionally well with the Balmain image. His gowns, tailored dresses and coats were the epitome of chic, but sadly this wasn't enough to boost the fashion house's profits in a dwindling market where couture was increasingly competitive. Ironically, Olivier Rousteing, who has so successfully restored Balmain's fortunes over the last decade, has cited Oscar de la Renta's exquisite couture as an inspiration to him on numerous occasions.

When de la Renta left in 2002, sales were plummeting and Balmain made the decision to pause its couture collections. (It didn't present at couture week again until Olivier Rousteing resurrected the tradition in January 2019.) Unfortunately, de la Renta left at a time when Balmain's ready-to-wear line was in turmoil. This was a market on which historic couture houses increasingly relied for profit,

LEFT This elegant deep-red outfit from Oscar De La Renta's Autumn/Winter 1995 collection shows his masterful grasp of both texture and form. The fitted velvet knee-length shift dress is worn with a voluminous silk-lined cord evening coat, trimmed with sparkling beads. The wide satin belt, gloves and matching statement necklace complete this perfectly tonal outfit.

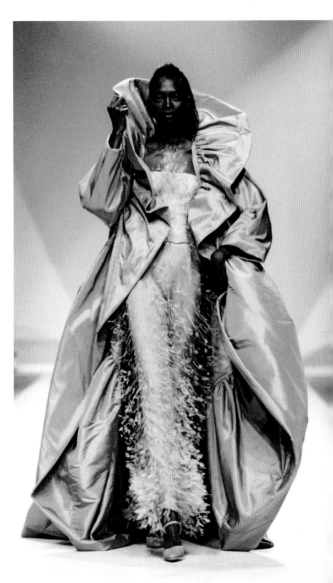

RIGHT Model Debra Shaw in a flamboyant couture outfit by de la Renta for his Autumn 1999 couture collection. The white feathered trouser suit is offset by a voluminous blue silk taffeta cape, with a high ruched collar that billows as she walks. This kind of outfit was referenced by Olivier Rousteing when he re-established the couture line at Balmain in 2019.

OPPOSITE This classic evening dress is typical of De La Renta's romantic designs from the 1990s. Shown as part of the Autumn/ Winter 1995 collection, the silk purple gown features a classic sweetheart bodice which flares to a full skirt, stiffened by layers of net petticoat. A delicate outer layer of chiffon, sheer on the arms but glamorously adorned with crystal swirls in silver and red covers the dress itself.

but the house had experienced a disastrous three seasons unde Gilles Dufour, who misguidedly sent clothes embellished with the words "bitch" and "whore" down the catwalk.

Next up as creative director was Laurent Mercier, who was, according to *Vogue*, an "ex drag-queen" and stage costume designer, who had "planned to breathe new life into a label which had traditionally been associated with a conservative, mature fashionista". Unsurprisingly, Mercier lasted just one season.

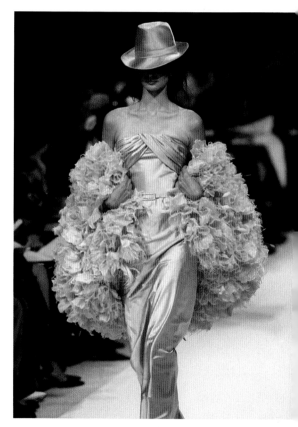

Things were looking dire at Balmain, which was on the verge of bankruptcy. In 2006, new CEO Alain Hivelin, who had been brought on board to salvage the brand, appointed Christophe Decarnin as creative director.

At 42 years old, Decarnin had headed up the design team at Paco Rabanne for seven years but was considering quitting the high fashion world. Now he was thrown into the deep end with only 45 days to design his first ready-to-wear collection for Autumn/Winter 2006. The change in aesthetic was

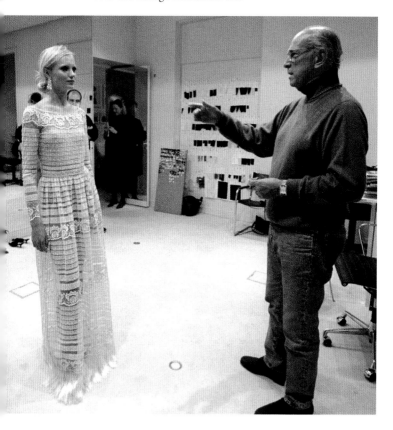

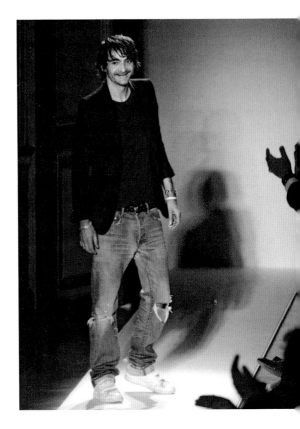

RIGHT Christophe Decarnin, who started Balmain's transformation from an old-fashioned couture house to the high-octane label that it is today. Here taking applause after his Spring/Summer 2009 show.

immediate. In the words of *Grailed* magazine in 2017:

"Decarnin presented a drastically different take on Balmain. Although he visited some of the brand's tropes … including elegant gowns, and heavy use of pleating, his penchant for leisurewear, club attire, and trademark hack-and-slash aesthetic were already beginning to form. Instead of regal high necklines, Decarnin's dresses featured heavy gold chains and fully open backs. Cocktail dresses were cut s short they barely qualified as dresses, and a heavy use of gold

silver, and black clearly showed his rock-n-roll inclinations."

Decarnin continued to build on his new rock chic aesthetic, developing a signature look centred around sharp leather jackets with ball-like shoulders encrusted with Swarovski crystals, ripped skinny jeans and heavily embellished T-shirts. Despite a colour palette that was predominantly black, white and olive, this was a glitzy and sexy take on couture, not dissimilar to what Tom Ford had done at Gucci a decade earlier. Decarnin knew that Balmain's calling card had always

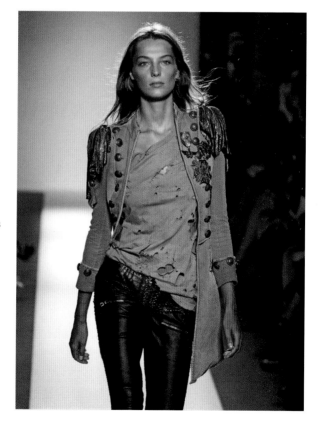

RIGHT This outfit is typical of Decarnin's posh-glamour style. Black skinny leather trousers are teamed with a heavily distressed khaki T-shirt and a military-style jacket with medal motifs. The crystal-embellished shoulders of the jacket give the impression of metallic epaulettes as well as accentuating the square-shoulder silhouette for which Balmain became famous under Decarnin.

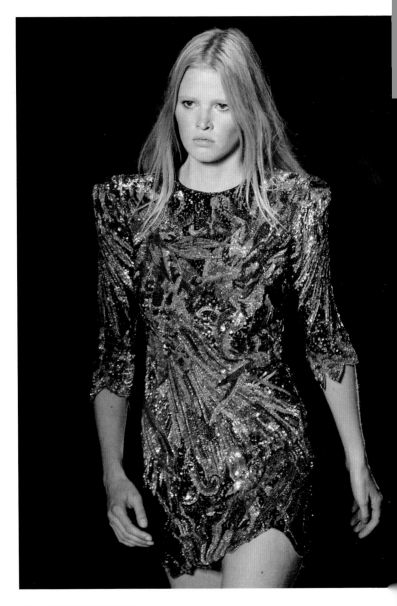

been its evening wear and he excelled at designing jewel-encrusted glamorous gowns with a 1980s flavour and just enough of a trashy edge to thrill his rich and famous customers.

The fashion elite went wild for the new look. Carine Roitfeld, editor of *Vogue* Paris, and her daughter Julia, became early fans alongside celebrities such as Kate Moss and Rihanna and a host of young and fashionable European royals and socialites. Ironically, given the new hype around Balmain, it really was only the rich and famous who could afford Decarnin's clothes. Even those accustomed to couture prices balked at $1,400 for skintight slashed biker jeans or $15,000 for his iconic beaded military jackets. Even Balmain's cotton T-shirts (artfully distressed) cost around $1,000.

Nevertheless many garments were flying off the shelves and by 2008 Balmania had overtaken the fashion world. Marcelo Maquieira, a buyer for an Amsterdam boutique, told the *New York Times* how a customer was robbed for her Balmain:

"She had just bought a very expensive Balmain piece … but as soon as she left the store a couple forced her to hand over the bag. They had obviously been watching and they wanted the Balmain."

Perhaps the truest testament to its success was that Decarnin's aesthetic quickly filtered down to the high street: stores including Top Shop and Zara mimicked his sequinned dresses and ripped jeans.

Decarnin also transformed the menswear at Balmain. The distressed biker jeans that had been such a hit in his womenswear collections were easily transitioned over to men's, and, in a savvy business move, they retailed at a far lower price point too. Similarly, many of Decarnin's rock-glam fashions, including his signature distressed T-shirts and badge-strewn military shirts, were easy to tone down and adopt into the menswear lines. It was a winning formula.

OSITE
patterned,
ellished
dress from
ng/Summer
9 clearly shows
arnin's love of
g. It is completely
red in green,
le, blue and
k sequins and
the exaggerated
e shoulders that
ediately mark it
as Balmain.

As *Grailed* succinctly put it, Decarnin had the ability to "create clothing that – while clearly fashion forward – is easily understood. Whether you were partying in Saint Tropez or going clubbing in Le Marais, as long as you had the cash, Balmain was a safe bet."

The continued hype from the fashion press, in particular Paris *Vogue*, kept Balmain at the top of the current fashion scene, and celebrities flocked to wear his clothes. But by 2010 Decarnin's "haute trash" styles had begun to look a bit common. As the *Guardian* put it in 2011: "Its chainmail catsuits were a self-parody."

Decarnin was not helped by the fact that his look had been so comprehensively ripped off on the high street. The clothes were still hugely expensive and he had lost his visionary stylist Emmanuelle Alt, to Paris *Vogue*, where she had taken over as editor. The writing was clearly on the wall when Decarnin failed to show up for his final catwalk show, Autumn/Winter 2011. An unspecified illness and the need to rest was given as the reason, but the collection had a different feel too, with less glam punk and an overall softer aesthetic that was not to every critic's taste. The announcement came soon after that Christophe Decarnin was to step down as creative director.

With rumours circulating that Balmain would choose its new creative lead from within the company, the *New York Times* pointed out that "luxury fashion houses are becoming less interested in promoting lively personalities than in protecting their own brands". A star designer clearly wasn't always the remedy for a flagging couture house – as Dior had recently learned to its cost after accusations of anti-semitism necessitated that John Galliano be fired.

When 24-year-old Olivier Rousteing, currently heading up womenswear at Balmain, was announced as Decarnin's successor, he became the youngest creative director in Paris

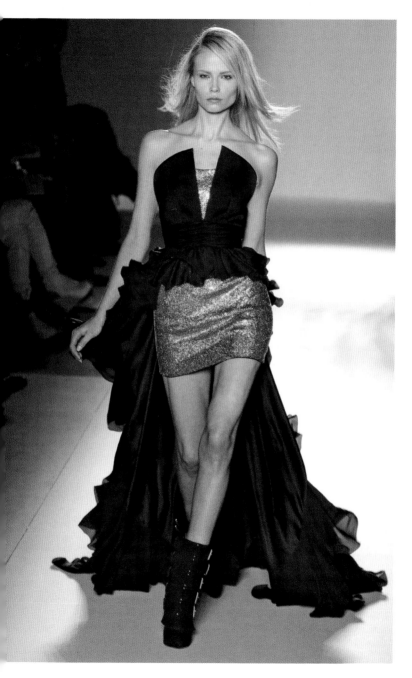

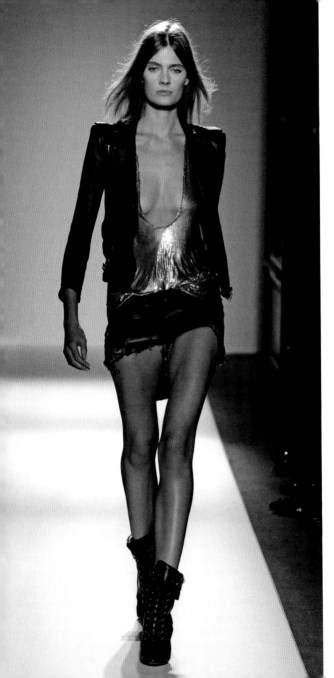

LEFT Another barely there outfit which exudes the sexy, grunge glamour that has won Balmain so many fans. The gold lurex top has a deep plunge neckline and sits atop a distressed raw-edged miniskirt that resembles a strip of remnant fabric. The model's fitted black leather jacket has a broad shoulder line which frames the rest of the outfit. Biker-style ankle boots finish the look.

OPPOSITE An army of Balmain models walk the catwalk for Autumn/Winter 2010, wearing outfits that scream expensive luxury. Tones of gold, red and black in blinding fabrics such as lurex and outfits adorned with lamé, sequins and brocade are offset by period-style delicate chiffon and lush velvet.

ince Yves Saint Laurent for Christian Dior as well as one of
the few designers of colour to head up a major fashion house.
He was also somewhat of an unknown quantity. But while
Decarnin had begun the transformation at Balmain, it would be
Olivier Rousteing who would take the label to a whole new level.

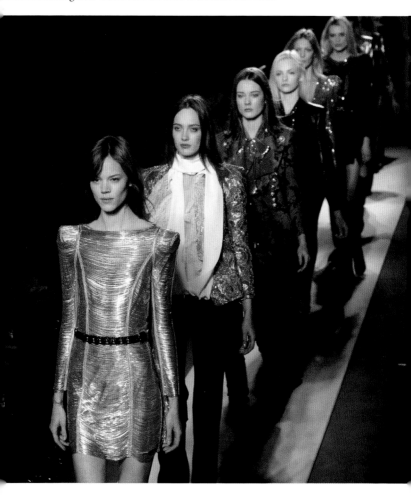

OLIVIER ROUSTEING

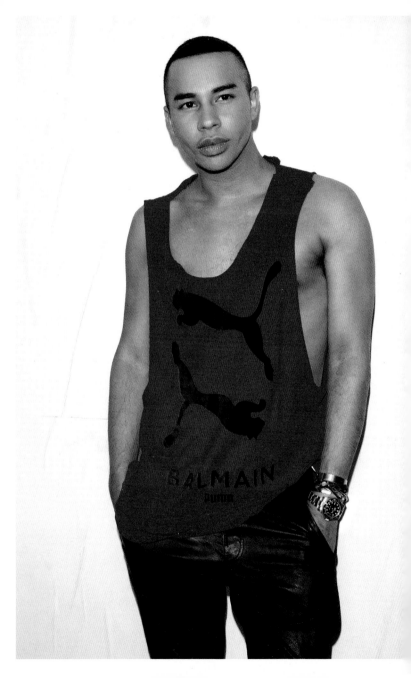

RESTORING BALMAIN'S FORTUNES

"I know a lot of people think I just take selfies but the reality is it's not that, I work so much, I'm such a perfectionist."
OLIVIER ROUSTEING 2018

When Christophe Decarnin left as creative director of Balmain in 2011, the fashion label was once again beginning to stagnate. Decarnin had successfully transformed the staid fashion house with his unique brand of slightly trashy glamour, but copies of his signature designs had become ubiquitous on the high street, and celebrities and the wealthy were no longer prepared to pay the stratospheric prices his jackets, jeans and T-shirts commanded. Balmain needed a new direction, and the person CEO Alain Hivelin chose to take over was the young and unknown Olivier Rousteing.

Born in 1996, Rousteing had been adopted by a well-to-do French family aged one, and later discovered that his heritage was part Ethiopian and part Somalian. (His emotional journey was documented by Netflix in the short film *Wonder Boy*.) He grew up in Bordeaux, moving to Paris to study at the fashion

OPPOSITE Olivier Rousteing at the Puma x Balmain launch in Los Angeles in 2019.

school ESMOD, which he left after a year because he found it creatively unfulfilling. From 2003 Rousteing spent five years at the Italian fashion house of Roberto Cavalli, eventually rising to the role of creative director of women's ready-to-wear before leaving and joining Balmain in 2009.

When he started at Balmain, Rousteing worked closely with Christophe Decarnin, who became something of a mentor to him because the two men had a similar aesthetic. But Decarnin's star was on the wane and his differences with Balmain's management, along with rumours of mental health issues, saw Decarnin abruptly leave the label in 2011. Rousteing was quickly promoted to creative director, both his youth and mixed-race heritage initially raising some eyebrows. As he told *Out* magazine in 2015: "People were like, 'Oh my god, he's a minority taking over a French house!'"

But, after Alain Hivelin firmly reiterated Balmain's confidence in the young designer, praising Rousteing's "talent and ability … and his great understanding and appreciation of the unique DNA of the brand", the feeling among fashion onlookers turned to cautious optimism and keen anticipation of what this new Wunderkind might do.

In a 2015 interview for the *Business of Fashion*, Rousteing admitted: "I did not know what it was to be a creative director, I was just a fashion designer."

But Rousteing rose to the challenge and started shaping his vision for the future of the brand, soon finding his direction. He was both aware of his responsibility to Balmain's customers and keen to impress the management who had given him such a big opportunity. He explained that his vision was to bring back the couture heritage of Pierre Balmain from the 1950s but reinterpret it for a completely new generation:

"What I wanted to do from day one was keep the DNA of the house, but the one before Christophe [Decarnin]. Pierre

OPPOSITE Rousteing has not only explored a wide range of fabrics and shapes in his fashion design – for example, crocheted knits, fluid sequinned dresses and highly embellished structured jackets, all shown here – he has also championed diversity on the catwalk. Pictured after his Autumn/Winter 2017 show with Jourdan Dunn, Nicki Minaj, Sara Sampaio and Winnie Harlow, the Canadian model and activist who has raised awareness around the skin condition vitiligo.

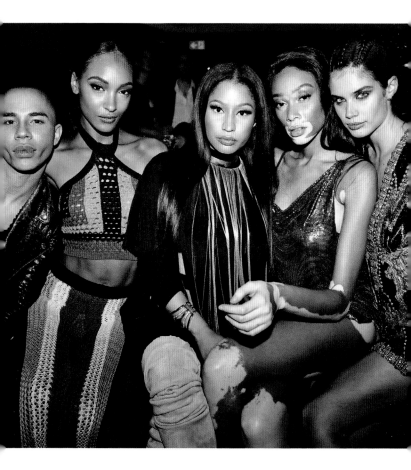

almain always believed in a really strong woman with this
autiful silhouette called Jolie Madame which was really,
lly important after the war … with tailoring and also the
uture aspect, quality and craftsmanship… Christophe was
ore into streetwear where I am more into glamour… I'm
ore into my generation also, he was into rock 'n' roll, I'm into
 hop and pop."

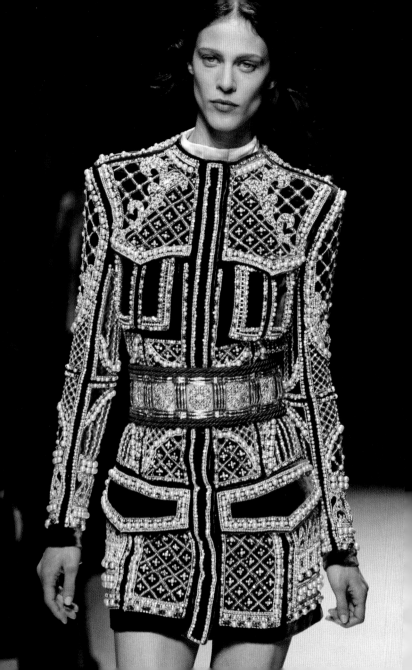

HE COLLECTIONS

ousteing's first collection was for Spring/Summer 2012 and he
ayed true to his intention to honour the heritage of Balmain.
doing so he alluded not only to Pierre Balmain but to Oscar
la Renta, who embodied the sophisticated ethos of the
shion house during the 1990s. As *Vogue* put it in the show
view, Rousteing planned to "bring a bit of class to this act",
d noted that: "Despite the familiar skintight silhouettes and
e short hems, the trash factor was gone."

Rousteing said backstage that his collection was about
mixing the tailoring of Mexico and the glamour of Vegas",
hich he achieved with heavily embellished, square-shouldered
reador-style jackets. The glitz was inspired by the flamboyant,
estern-themed rhinestone-studded suits designed by Nudie
ohn, who, from the 1950s onwards, created iconic outfits for
e likes of Elvis Presley and Elton John. There was, however, a
w softness in Rousteing's collection and *Vogue* predicted that
is, along with a nod to the hourglass silhouette which had
ade Balmain's name in the beginning, "may prove the key to
ousteing's success".

As Rousteing continued through his first couple of
llections, Balmain's new silhouette emerged. For Autumn/
inter 2012 shrunken biker jackets were replaced with
asculine, oversized tailored versions, boxy in style with
uared-off shoulders. These were softened by elegantly draped
ousers in devoré velvet, knitwear and leather, exquisitely
bellished with crystals and pearls.

By Spring/Summer 2013, Rousteing's jacket shoulders had
dened considerably, channelling the power dressing and
morous supermodels of the early 1990s, and completed
th high-waisted mannish trousers. He also cited a Cuban
fluence with graphic black and white harlequin prints
spired by traditional floor tiles, and cutaway fine raffia dresses

OPPOSITE
Rousteing's first
few collections saw
Balmain reach a new
level of luxe dressing.
This neatly tailored,
gold-belted minidress
from Autumn/Winter
2012, reminiscent
of the English Pearly
Kings and Queens,
features exquisite
embellishments
including pearls and
crystals in patterns
of diamonds and
squares.

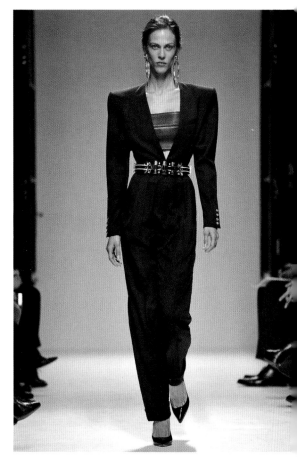

in vibrant yellow and white that were so delicately woven they could be mistaken for lace. The feeling was glamorous in the same way that Versace and Christian Lacroix achieved: bold but not trashy.

For Autumn/Winter 2013 the proportions of Rousteing's jackets, and the quantity of beaded embellishments he applied

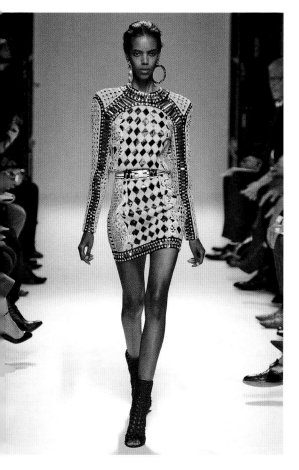

LEFT This pale blue and silver woven cutaway minidress, also from Spring/Summer 2013, features a harlequin print, inspired by traditional Cuban flooring. It is intricately made with metallic links and studded crystals on the collar and hem.

ew ever more exaggerated. Patent fuchsia leather was abroidered with diamond-shaped crystals, while quilted silver nics shimmered. The hourglass silhouette was accentuated rther with wide gold belts tightly pulling in the model's ists. These were the party clothes for which Balmain was nowned and the bling factor was edging back up the scale.

RIGHT For his standout Autumn/Winter 2013 collection, Rousteing started using even wider shapes as well as multilayered patterns. This oversized quilted black jacket, with metallic thread woven into diamond shapes, is worn on top of a plunge-neck tunic with another geometric pattern. The gold trousers echo the rest of the outfit, emphasizing the wealth and decadence of Balmain.

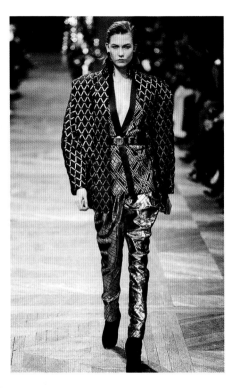

By Spring/Summer 2014, however, Rousteing looked to be toning things down somewhat as he admitted backstage that he wanted to "explore something casual and sporty. It's less evening and more real. It's more me."

For this season shapes had softened, with masculine jackets replaced by black and white belted leather cardigans in a graphic print resembling the houndstooth tweeds of 1950s couturiers such as Chanel and Dior. The heritage meets modern luxe aesthetic was reinforced by a quilted leather cropped jacket and dress combination with oversized gold buttons and plenty of chunky gold-chain trim that felt like

RIGHT Shown here are two more examples of the heights of intense colour and luxurious texture that Rousteing achieved in his Autumn/Winter 2013 collection. A quilted purple leather high-collared top is embellished with crystals embroidered in a diamond pattern, and a two-tone pink-and-black ensemble takes the pattern head to toe. Both models wear harem pants and wide wrap belts which, along with the structured shoulder line, give the collection the feel of the early 1990s.

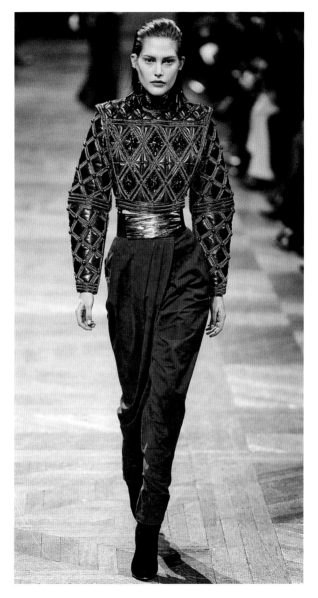

very modern Chanel, especially in monochrome.

By now, mostly thanks to his social media presence, Rousteing's own celebrity was beginning to rival that of his famous clients. His new best friend, and star of his advertising campaign, Rihanna, was heading for the front row – sadly on that occasion the Paris traffic thwarted her and she missed it – even as Rousteing proclaimed his new autonomy backstage:

"I'm French, I'm Black, and I'm proud to be at Balmain, but this is a message of freedom and globalism."

Rousteing's Autumn/Winter 2014 collection included safari leathers in tones of khaki, green and black, mixed with accents of animal skin. The jungle aesthetic was kept current by a heavy dose of street hip-hop, and the obligatory bling had given way to something more subtly glitzy. As well as tough motorbike jackets and cargo pants, Rousteing offered a contrasting classically tailored silhouette, with skirts cut unexpectedly to the knee – although there were buttock-skimming minis for those who wanted them – and jackets tightly belted to flare peplum style over the hips. As always, the clothes were texturally rich and featured plenty of embellishments in the form of gold chains and silk cord. It was a confident collection with a direct message from Rousteing, summed up by Nicole Phelps in *Vogue*: "From here on out, he'd be doing things his way."

The next few seasons sealed the reputation of Balmain as the go-to label for socialites, celebrities and everyone in between, or at least those who could afford to buy into the hype. Outfits ranged from cutout body-con bandage dresses to Rousteing's signature macramé, so laden with crystals that models struggled to move fluidly. As always, luxe leather and suede reigned supreme, in graphic prints and bold blocks of colour. The trademark house sparkle showed no sign of dimming, crystals being liberally applied to all manner

OPPOSITE Spring/ Summer 2015 saw Rousteing embrace graphic stripes and colour blocking. Jourdan Dunn is shown here in a vertically striped black, white, and yellow halterneck jumpsuit, entirely covered in crystals.

OVERLEAF Rousteing continue experimenting wit colourblocking and bold stripes into hi following collectio for Autumn/Winte 2015, presenting a series of richly hue pleated gowns whi referenced Paris during the 1970s.

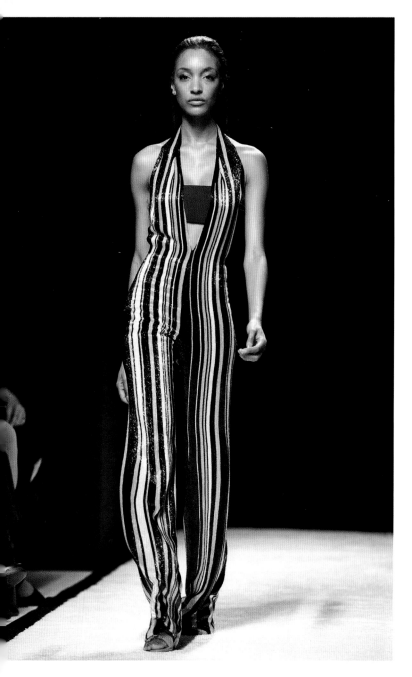

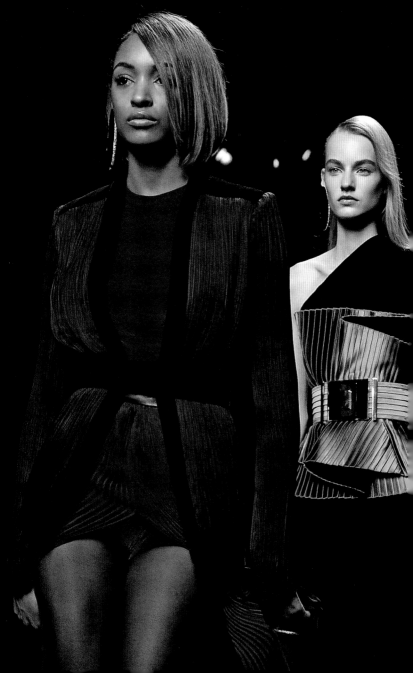

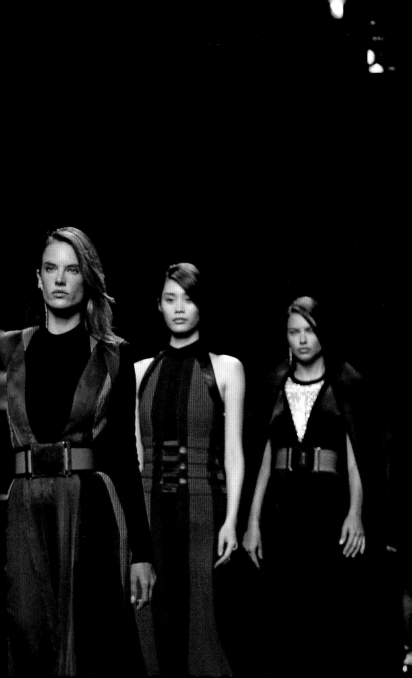

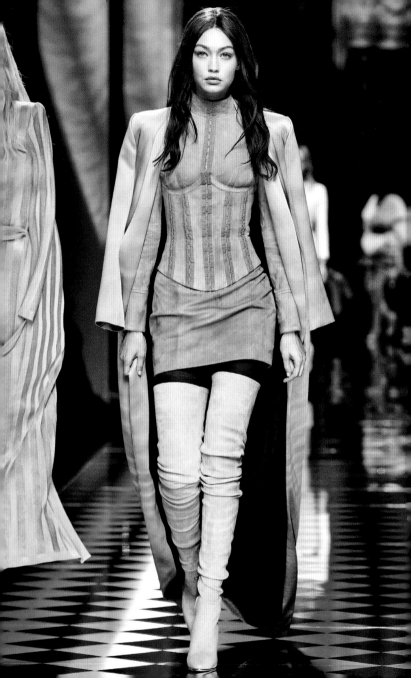

of garments. On the softer side, pleated jersey knits hung beautifully as models glided gracefully down the catwalk and sheer panelling allowed a cheeky glimpse of a nipple. Finally, a new trademark for Balmain: layers of tiered chiffon ruffles on dresses, and billowing capes, both of which encouraged the perfect flounced entrance.

Rousteing's silhouette had always been sensually curved, in keeping with the original 1950s' Balmain femininity, but in Autumn/Winter 2016 he pumped things up in honour of his new muse, Kim Kardashian. As the designer explained backstage: "Women of today are really curvy, and they're an inspiration, like hip-hop stars, reality stars."

For his collection this translated into waists tightly sculpted by woven leather and suede corsetry and miniskirts widened with artificially padded hips. The palette of pale neutrals echoed Kardashian's favourite colours. Rousteing's enthusiasm for decorative effect had once again come to the fore, with a glut of ruffles, fringing, feathers and lace, and pearls taking the place of the usual Swarovski crystals.

Under Rousteing's inspired creative direction and genius for social media marketing, Balmain's profits were growing fast. In June 2016 the label had been bought by Mayhoola, an aspirational investment group, supported by the Qatari royal family, who already owned Valentino. Adding Balmain to its stable made the emir of Qatar's goal obvious – to own a big chunk of the luxury fashion market – but for Balmain the bottom line was that the fund was ready to throw money at the label's global expansion. The first obvious evidence of more investment was that the Spring 2017 catwalk show had added 20 more looks, taking it to a total of 80.

This was another safari-toned collection, at first full of outfits in muted khaki and dusty oranges, though later the catwalk was lit up with evening wear in jewel-like emerald,

RIGHT Spring/Summer 2017 was Balmain's first after being bought by Mayhoola, the investment company linked to the Qatari royals. The safari-toned collection included more relaxed outfits such as this dusty orange bandage dress in silk and knit jersey. Worn over colour-matched leggings, it has a tight wrap belt and draped matching cape.

OPPOSITE Spring/Summer 2017 also included more of Rousteing's extravagant, crystal-embellished garments such as this draped and belted wrap jacket in bold, jewel-like tones of orange and pink.

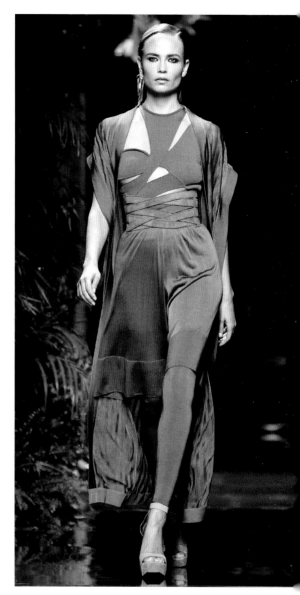

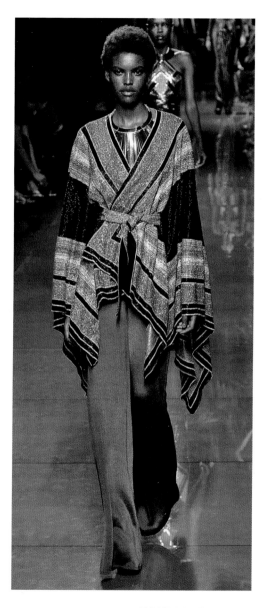

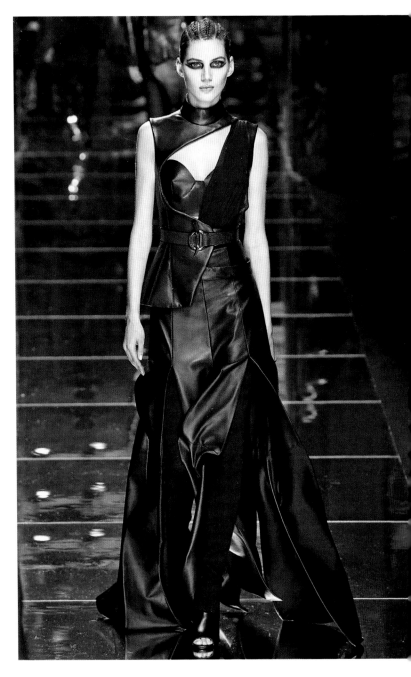

apphire and red. Statement snakeskin in glossy brown and green was a key theme, but there was also a softer option on offer in the form of draped suede jackets, wrapped around the torso or waist and held in place by tightly wound wide belts. Rousteing's cutaway and bandage motifs were still popular in a collection that celebrated colour rather than sparkle.

For his next few collections, Rousteing started to experiment with different shapes, still keeping the sequinned glitz that fans expected while loosening up at least some of the silhouettes from the form-fitting designs of previous seasons. For Autumn/Winter 2017, colours were rich and fiery with luxe fabrics draped and layered on top of each other in a textural fanfare that included mohair, suede, snakeskin, and oversized shearling. By Spring/Summer 2018, the palette had switched to grey and monochrome, and included patterns such as graphic checks and Breton-inspired stripes, as well as dresses with bold layered ruffles at the hemline or shoulder. Essentially though, despite the nods to different eras – 1990s grunge, for example – there was a continuity to Rousteing's collections which meant that every new presentation built on the themes and successes of the one preceding it.

For Autumn/Winter 2018, however, this dramatically changed. As befitted a traditional couture house, there had always been an element of heritage in even the most modern of Balmain's collections, but this time Rousteing went full-on futuristic. With the collection ostensibly placed in the year 2050, Luke Leitch for *Vogue* labelled the models as "sci-fi sirens uniformed in neon-spectrum plissé, holographic PVC, and holographic paillettes".

But Rousteing was unapologetic and admitted to having fun designing the clothes, secure in his position as the hottest designer in town. As one of the sequinned T-shirts on the catwalk announced: "We are the new generation."

OPPOSITE The cutaway and bandage style of dress has become synonymous with Balmain. This black leather ensemble from Autumn/Winter 2017 features an asymmetric belted sleeveless top, sculpted around a leather bustier with a single sashlike strip of ruched chiffon worn across one shoulder. The long panelled leather skirt is split to the thigh.

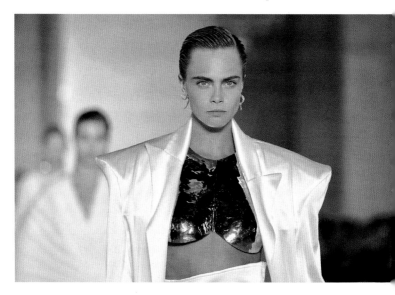

BELOW Cara Delevingne opened the Spring/Summer 2019 Balmain show wearing a beaten metal bodice, inspired by Cleopatra, beneath an oversized white satin jacket with elongated, pointed shoulders.

With Rousteing's reputation, and Balmain's fortunes, riding high, 2019 saw a homecoming of sorts when Balmain returned to the world of haute couture, appearing on the most elite fashion week schedule for the first time since 2002. During the late 1940s and early 1950s, Pierre Balmain had established a couture house as esteemed as that of his contemporary Christian Dior, and Rousteing clearly wanted to draw on that heritage. He told *Vogue* magazine:

"We're living in a world where we are almost scared to look at the past because everybody's so stressed about what is the future, what is next. I am looking at the past to understand the present, and to actually dream of a better future."

Drawing on the designs of both Pierre Balmain and, several decades later, Oscar de la Renta, Rousteing managed that blend of modern and heritage which is not always easy to achieve. For example, feathers and bows, both motifs beloved of Pierre Balmain himself, were supersized and transformed

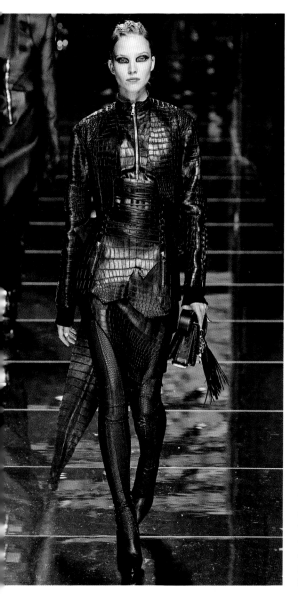

LEFT Animal skins have always been a favourite of Balmain and epitomize sensual luxury. This head-to-toe reptilian look from Autumn/Winter 2017 has a cropped zipped tailored jacket, a corseted tunic and an asymmetric hem. Snakeskin legging boots finish the look.

RIGHT Helena Christensen, seen here walking for Autumn/Winter 2020, wears a glamorous, crystal-smothered jacket, with a plunge neckline, spiked shoulders and balloon sleeves, narrowing to exaggerated flared cuffs. The matching trousers and wide belt make this a sophisticated take on Balmain bling.

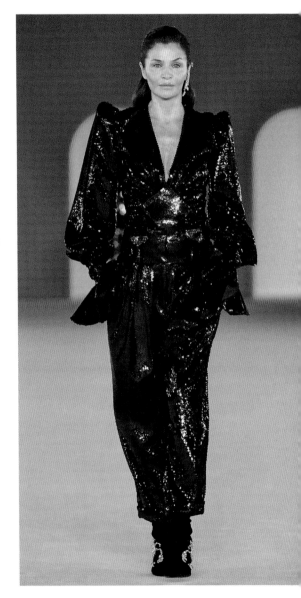

into exaggerated versions of the originals. A tailored jumpsuit was an extraordinarily ornate feathered creation, explained by the designer as "a mix of knit, crochet and feather work, with Swarovski pearls and crystals woven through the material to elevate it".

The textiles Rousteing used for his debut couture collection ranged through heritage tweed to denim and futuristic quilted plastic. The oversized silhouettes, with ballooning ruffles and pleats, were reminiscent of Valentino, another couture house patronized by the rich and famous. Balmain's return to haute couture took the label to a new level and Rousteing seemed to have matured too when he acknowledged at the end of the *Vogue* interview:

"You are not doing something for the trend or the hype, you are doing something for the timeless part."

Another new introduction, and one which added to the

BELOW Rousteing is committed to as much diversity as possible on the Balmain catwalk. To this end he has invited back many supermodels from the 1990s. Shown here with the designer are Erin Wasson, Julia Hengel, Helena Christensen, Caroline Ribeiro, Esther Cañadas and Liya Kebede.

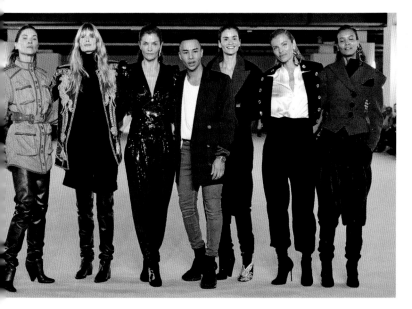

BELOW The Balmain monogram logo and print was redesigned in 2018 and quickly featured across a wide range of garments, many of which can be seen in this closing shot from Balmain's Spring/ Summer 2021 show.

timelessness Rousteing sought, was the new stylized Balmain logo and monogram print, designed by Parisian agency Adulte Adulte and launched in 2018. Balmain was following a long tradition of monogrammed goods produced by other luxury brands, including Gucci, Chanel, Louis Vuitton and Fendi, and this was an obvious way to boost the house profile as well as giving it a heritage touch. The logo of an overlapping capital P and B, centred in a black circle on a white background, was described by Rousteing in a press release:

"It is a contemporary, pared-down and daring logo for

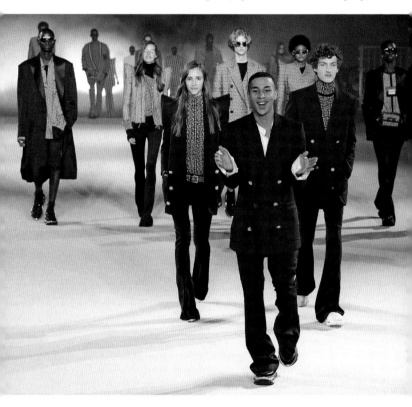

The Balmain monogram logo and print was redesigned in 2018 and quickly featured across a wide range of garments, many of which can be seen in this closing shot from Balmain's Spring/ Summer 2021 show.

his long-established maison, preserving the latter's original heritage while making it clear for everyone that it stands for a contemporary luxury French fashion label."

The logo was also adapted into a monogram version to create a graphic and instantly recognizable print for a new generation of label lovers keen to make clear that they were part of the Balmain Army.

His constant presence on Instagram and TikTok made Rousteing's personal life just as fascinating as his new creations for Balmain, and in the autumn of 2019, a unique insight into the designer's life was revealed through the documentary *Wonder Boy*. The film, covering a year of Rousteing's life, showed not just his glamorous world of fashion and socializing but the designer's emotional search for his adoptive parents. Having grown up as a mixed-race child in a white household, this was obviously a hugely important quest for Rousteing and his discovery that he is in fact African, born of an Ethiopian father and Somali mother who became pregnant at just 14 years old, was a deeply poignant moment in the film.

Wonder Boy was subsequently released on Netflix in June 2020 and went a long way to demystifying and humanizing Rousteing who, with his model good looks, cult following on social media and celebrity lifestyle, might have come across as unreachable. In an interview with *The Hollywood Reporter* in 2021, he admitted:

"I really kind of crystallized myself, if I can say, into a kind of box of just the glamour of Olivier and the glamour of Balmain. Everything is sparkle. Everything is shiny. There's never a sadness. It's like a party all night long, or all life long in a way. This is maybe a character that I wanted to play because I was hiding all my fears. And I was just like, I'm going to break that image that I created of myself."

This new insight into his own background clearly affected

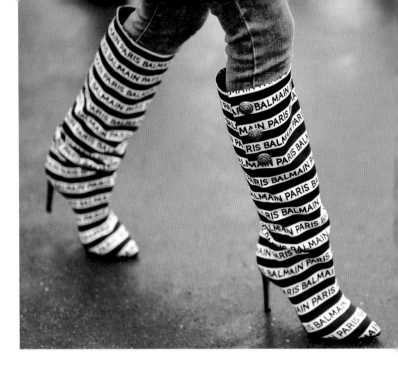

Rousteing's designs and he immediately included more African influences in his collections. More importantly, it renewed his devotion to promoting diverse ethnicities in his shows and campaigns, something for which he had long worked hard. For example, his Spring/Summer 2019 campaign, shot by Berlin-based photographer Dan Beleiu, featured Rousteing standing behind model Cara Delevingne, covering her naked breasts with his hands. The impactful shot, a recreation of Janet Jackson's album artwork for *Janet*, celebrated the union between white and black skin.

Rousteing explained more about his personal journey of discovery:

"I was raised in Bordeaux, a really conservative city, but at the same time it was important to show the multicultural

spect that I have in my blood. It's my vision of being a citizen of the world, being proudly French, proudly half Ethiopian, proudly half Somalian."

Rousteing's acceptance of his own mixed identity and his admission to *Vogue* that he "grew up obsessed with questions regarding heritage, race, belonging, and fitting in" is clearly reflected in his collections from the early 2020s.

For Balmain's Autumn/Winter 2020 show, Rousteing took the traditional French aesthetic and put his own unique modern spin on it. Fabrics and colours were typically upper-class Parisian, including an expensive-looking shade of camel, trimmed in smart black, and luxe double-breasted coats adorned with large gold buttons, albeit also exhibiting the exaggerated Balmain shoulder. There was an homage to Yves Saint Laurent too in the shape of oversized Le Smoking suits, and traditional prints alluded to the country pursuits of high society with Hermès-style horse and chain motifs.

BELOW Balmain logo bags have become commonplace style statements in fashion week street style roundups. Two examples are shown here: a rectangular studded bag with logo clasp plus heavy chain strap and a circular monochrome leather bag with woven strap and central "B" motif.

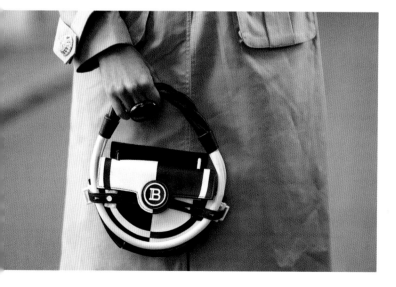

When the COVID pandemic hit, Balmain, with the digitally savvy Rousteing at its helm, was uniquely well-placed to embrace the new world of the virtual, live-streamed catwalk show. Marking the couture house's 75th anniversary the show, which streamed on Instagram Live and TikTok as well as Balmain's own site, began with models slowly meandering for the camera in 1970s-style clothes, all printed with the Balmain monogram. Taking advantage of all the opportunities an immersive digital show offered, Pierre Balmain's voice echoed over the soundtrack in both French and English with statements such as "There is also a touch of sex in fashion now."

This was certainly true of the rest of the show, which was full of spike-shouldered tailoring in bright neons, tight flared trousers worn with vertiginous heels, sculptural leather bustiers and fitted denim shorts. Glitz was obviously still appealing to Balmain's audience, despite the lack of lockdown partying, and the collection's glittering jackets and knitwear reputedly carried a total of two million Swarovski crystals.

Along with continuing to design endlessly glamorous and covetable clothes, Rousteing has increasingly used his platform over the last few years to comment on issues close to his heart, including how people can defend themselves against the challenges of online body and image dysmorphia. For his Autumn/Winter 2022 collection he offered an almost literal protection in the shape of quilted and padded jackets and bandage-style tops and dresses that built up a kind of textile armour.

These designs were also influenced by the horrific injuries Rousteing suffered in October 2020, when a fireplace explosion at his home burned his upper body. To process the trauma took him a year, and when he finally posted an image of his heavily bandaged body on Instagram, he admitted how

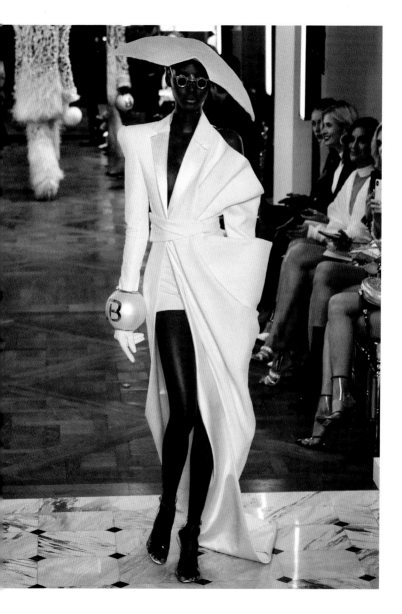

RIGHT This intricate mesh catsuit and matching jacket from the couture 2019 collection is heavily embellished with pearls and trimmed with maribou feathers. The white pill-box hat alludes to heritage shapes but instead of a delicate veil Rousteing has taken inspiration from a beekeeper's protective hat complete with exaggerated honeycomb mesh.

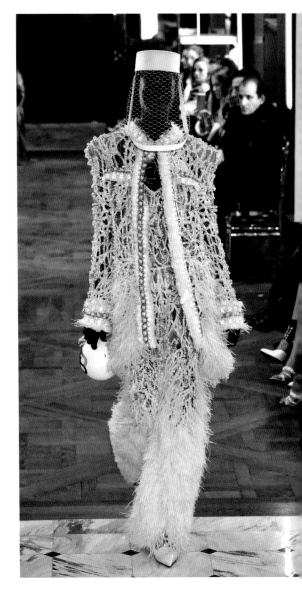

he accident had changed him, reflecting in his captions on fashion's increasing obsession with bodily perfection.

"I did everything to hide this story from as many people as possible and trying to keep the secret with my teams and friends for too long. To be honest I am not really sure why I was so ashamed, maybe this obsession with perfection that fashion is known for and my own insecurities."

When he gave an interview about the explosion to British *Vogue* in October 2021, he credited his remarkable recovery to the healing power of creativity: "Today, I feel so free, so good and so lucky. I'm beginning a new chapter with a smile on my face and a heart full of gratitude."

As well as confronting issues with diversity, ableism and unrealistic expectations of perfection, the fashion world has increasingly had to admit to other challenges, including the industry's effect on climate change and the need to find sustainable resources and means of production. Backstage at his most recent Spring/Summer 2023 show, Rousteing admitted that he sometimes struggled to reconcile his work with these bigger concerns.

"We all saw climate change this summer. We all saw fires around the world. And coming back with a show in September, thinking about whether our pants are going to be high-waisted or low-waisted – it seems a bit futile to me."

Nevertheless, Rousteing is trying hard. He admitted that not all of his latest collection was sustainable, but he had sourced fabrics made from paper, wicker, and even banana. The big question is, of course, how to find a way to enjoy and produce fashion sustainably for the long term. Rousteing's ongoing project is, he explained, to radicalize his supply chain for the better – and with Balmania as rampant as ever, let's hope he finds a way.

ABOVE Rousteing has gained a cult following among men as well as women. He is pictured here at the after party for his Autumn/Winter Menswear show with model Sofia Ritchie, racing driver Lewis Hamilton, and rappers ASAP Ferg and ASAP Rocky.

MENSWEAR

In June 2015 Rousteing once again sent a dedicated Balmain menswear collection down the catwalk as part of Men's Fashion Week. The company was hoping to build on the consistent growth the label had achieved among men since 2008, when Christophe Decarnin introduced a bold menswear aesthetic, which by 2015 accounted for 40% of Balmain's business.

When Decarnin originally announced that he had his sights on menswear, critics were sceptical that the label could transition to a male market because the glitzy, punk-trash reputation of the brand was very female-oriented. But the signature biker jeans, oversized racoon-trimmed parka and embellished T-shirts all proved a hit, and celebrities including David Beckham and Kanye West quickly adopted the look.

When Rousteing took over in 2011, the focus on menswear had slipped and fashion buyers had to make do with static

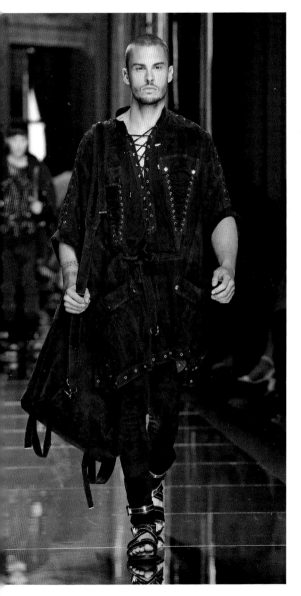

LEFT In this image from the Spring/Summer 2017 menswear show, French model Baptiste Giabiconi wears a gladiator-feel black laced suede jumpsuit, with eyelet detail on the breast pockets and sleeves, complete with gold-strap sandals.

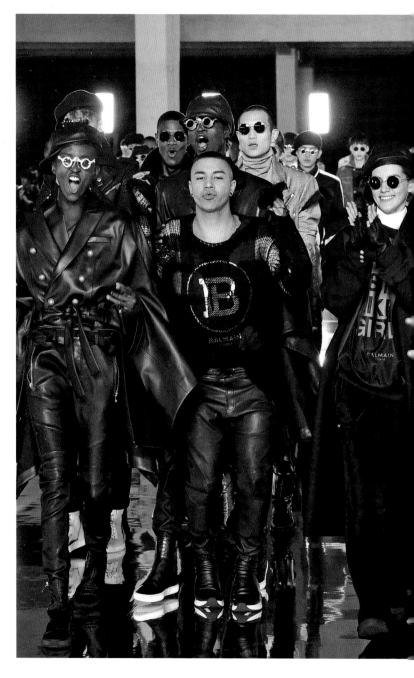

ollections and viewings by appointment only. But by 2015 ousteing had acquired a cult celebrity following, which ncluded as many men as women, so it seemed timely to give hem their own catwalk moment. For the debut show model lessandra Ambrosio and socialite Peter Brant Jr. both walked, nd Kris Jenner was seated prominently in the front row.

The collection, resort-focused and interspersed with a few arefully placed women's looks, was described by the *New ork Time*s as: "a safari-inspired mélange of complicated raftsmanship (with rope details and spangles) and rough-and-umble khaki (albeit in luxurious suede and skins)".

The paper went on to quote Rousteing's explanation: "I just anted to have an explorer, a new aventurier."

In 2015, Rousteing summed up how he saw men's fashion in new glamorous social media world:

"I've been noticing what you could call the evolution of the ew aristocrats'. Unlike traditional aristocrats, this diverse and clusive grouping of stylish men knows how to confidently end together looks pulled from both their fathers' wardrobes nd the streets."

In response, Balmain's menswear silhouettes have odernized the glamorous couture heritage of the brand by aming wide-shouldered, double-breasted jackets and smoking ckets with baggy pants in luxe fabrics. Rousteing elaborated:

"I turned to more 'regal' fabrics, including rich velvets, silks nd cashmere, but I've worked to maintain that same easy vibe, part by relying on oversized and relaxed cuts."

As with all traditional luxury fashion houses, incorporating a reet element has become essential at Balmain. Rousteing, who heavily influenced by hip-hop and other music cultures, has hieved this with his signature drop-crotch pants, cashmere anies and motorbike jackets. If Balmain's soaring fortunes are ything to go by, it seems to be a winning formula.

OPPOSITE Olivier Rousteing has successfully revived menswear at Balmain, creating a strong look where expensive tailored garments are juxtaposed with logo-heavy streetwear. The designer is pictured here surrounded by models after his Autumn/Winter 2019 menswear show.

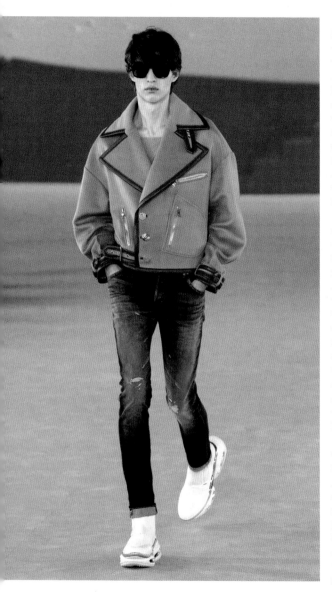

LEFT A typical luxe causal look from Balmain. The faded, narrow jeans are teamed with a blouson, aviator-style camel jacket in fine wool, trimmed with brown leather and gold zips and signature buttons. White and silver moulded trainers finish the look.

OPPOSITE This deconstructed tuxedo in pale, almost, metallic satin, from Autumn/Winter 2024 teams the classic tailored silhouette of a French couture house with a relaxed athleisure vibe. The trousers narrow to the ankle to meet gold double-strap sandals which complete the look.

OVERLEAF Models including Kendall Jenner, Gigi Hadid, and Jourdan Dunn pose after the runway presentation for the launch of the 2015 collaboration between Balmain and high street chain H&M.

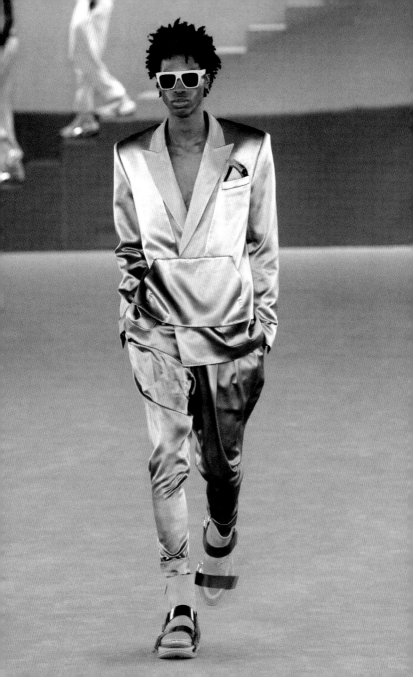

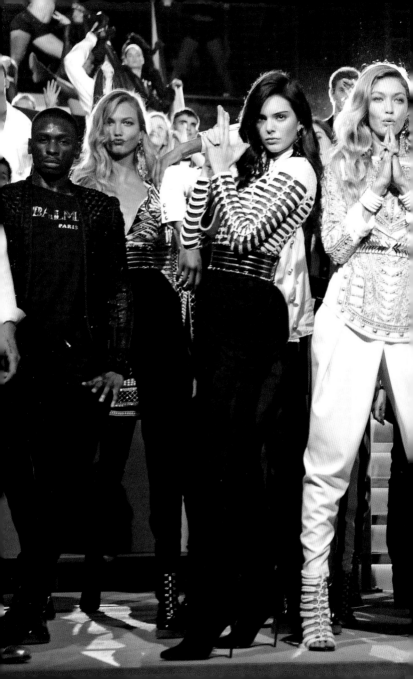

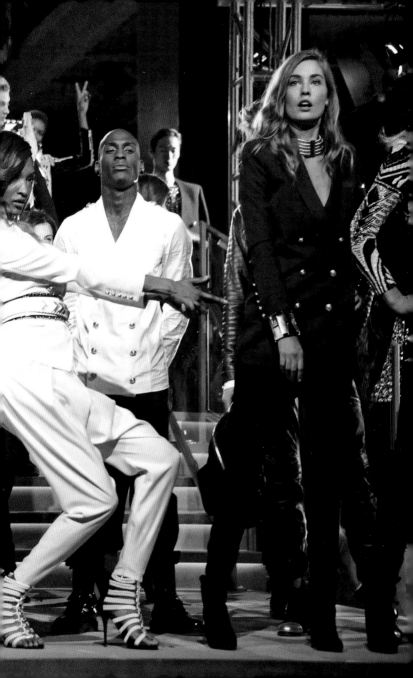

COLLABORATIONS

Collaborations between high-end luxury labels and a range of other fashion brands and lifestyle products have become an increasingly commonplace way of raising both a brand's profile and its profits, and over the last few years Balmain has worked on a variety of joint campaigns.

Perhaps the most successful partnership was with global fashion store H&M in 2015, which brought highlights from Rousteing's first eight seasons at Balmain to the high street. In a press release, Rousteing elaborated on his egalitarian vision for a stylish H&M Balmain Nation, calling his designs:

"A complete collection that can be worn by different men and women on different continents, all part of the same world I wanted to stay true to the DNA of Balmain, richly detailed, powerful and yet effortless."

Catering to both men and women, the collection was full of Rousteing's signature shapes, including glitzy minidresses, quilted and sparkling gowns and wide-shouldered tailoring. Thanks to the endorsement of celebrities such as Kendall Jenner, Kim Kardashian and Jourdan Dunn, the collection was an immediate success, with the H&M site crashing from the amount of hopeful buyers soon after its 8 a.m. launch. Shoppers also queued around the block at H&M stores, and inevitably garments soon landed on eBay at double the price, such was the power of the Balmain Army.

Since then, other notable collaborations have included a range of crystal-laden sexy lingerie for Victoria's Secret in 2017 and a boxing-inspired collection for Puma in 2019. Rousteing himself appeared in the sportswear campaign alongside Cara Delevingne, both looking fiercely at the camera as they modelled a graphically printed red, black, and blue collection. Fittingly, the tagline for the collaboration was "fighting the good fight". Rousteing explained in a press release how the

OPPOSITE As Rousteing's muse, Kendall Jenner was the obvious poster girl for the Balmain x H&M campaign. Pictured here in a revealing yet elegant black velvet-edged satin tuxedo with bandeau top.

OPPOSITE The H&M
collaboration was
one of Balmain's
most successful,
appealing to both
men and women. This
menswear look of a
red and black leather
motorbike jacket
over a monochrome
chevron patterned
knit is typical of the
capsule collection
which captured the
essence of the luxury
fashion label.

empowerment that boxing brought to individuals echoed Balmain's vision:

"Today, we do need to push back, protect inclusion and defend everyone's right to be exactly who they want to be. Diversity should always be celebrated and fought for. That's always been a key message for me, and it is at the core of this collaboration."

In another sportswear collaboration in 2021, a couple of years after Balmain's newly designed monogram print exploded onto the catwalk, Rousteing included the graphic in a limited edition luxury skiwear collection with French outdoor brand Rossignol.

Several of Balmain's most recent link-ups have been more ironic, juxtaposing the luxury of the fashion house with pop culture. A 2022 collection with Barbie featured a palette of pinks and print graphics emblematic of the iconic doll and its packaging, but the silhouettes Rousteing used in the collection were signature Balmain.

Similarly a collaboration with Pokémon, which debuted on the Spring 2023 catwalk, mixed the bright colours and cheerful character motifs of the video games with Balmain's monogram print and trademark marinière stripes. Rousteing admitted to being a fan of the optimistic outlook of the Pokémon world, which made him express the wish that the clothes would become a "reminder of those past moments of hope".

Other joint projects have included a Balmain version of Apple's Beats headphones, a joint cosmetics range with Kylie Jenner, and a 12-colour capsule lipstick collection for L'Oréal Paris. Lastly, as well as producing stylized versions of the iconic bottle for French mineral water Evian, Rousteing sent a white dress made entirely from recycled plastic Evian bottles down the Spring/Summer 2023 catwalk.

Rousteing's work on costumes for stage and screen have also inspired limited editions. These included reproductions of the outfits Beyoncé wore to perform at the 2018 Coachella festival, a capsule collection of fringe-laden, Western-themed clothes based on Rousteing's designs for Netflix's *The Harder They Fall*, and even a homage to one of the designer's favourite shows: *Stranger Things*.

Rousteing's work in conjunction with names other than Balmain hasn't just been about pop culture or the high street, however. When Rousteing was invited as a collaborative guest designer for Jean Paul Gaultier's Autumn/Winter 2022 couture collection, he showed he has a masterful command of haute couture, presenting a critically acclaimed modern interpretation of Gaultier's greatest hits.

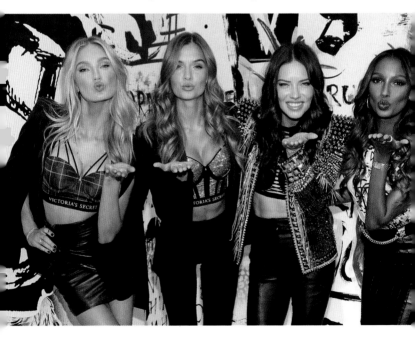

SOCIAL MEDIA

One of the undeniable reasons for Rousteing's success at Balmain is his use of social media to promote the brand. Aged just 24 when he was appointed creative director at Balmain, Rousteing is firmly part of the internet-savvy, digital generation. Since joining Instagram in 2012, he has made it his platform of choice – at the time of writing he has 8.7 million followers – where he has documented his friendship and personal interactions with a host of celebrity and influencers including Rihanna, Kendall Jenner, Kim Kardashian and Gigi Hadid. The informal outtakes, selfies and stories which Rousteing and his famous friends posted massively raised the profile of the brand as well as giving a uniquely informal insight into celebrity and high-fashion lifestyles.

He told the *Evening Standard* in 2019:

"I was so young when I started at the brand I thought let's share something that the others (creative directors) don't want to share... my morning routine, my behind-the-scenes. I wanted to show if it can happen to me it can happen to you. It was a really inclusive message."

Nevertheless, Rousteing has also expressed his misgivings about fashion posts on Instagram, and was quoted in the *Wall Street Journal* in 2018:

"Five years ago, there was an authenticity, where no one was paid to post a product. Everybody was posting what they believe in, Instagram is not what it used to be."

He also pointed out that Balmain had not yet joined other luxury brands in buying ads on the site, emphasizing the marketing influence of the personal post: "The picture you're posting is not only about a vision of your world, but is also product selling."

Always looking for new ways to take advantage of technology, Balmain introduced Shudu in 2017. The world's

first digital supermodel, she was created by photographer Cameron-James Wilson and "dressed" by CLO Virtual Fashion, a design company that creates hyper-real 3D dimensional simulated clothes. Dubbed the world's first virtual reality supermodel, Shudu has her own Instagram profile boasting 237k followers and has even broken out into magazine editorial shoots and other fashion campaigns.

A year later Balmain added two more virtual models named Margot and Zhi. The trio is described by the fashion house's website as "our new virtual icons … who mirror the beauty, the rock style, and the confident power" of Balmain.

2018 also saw Rousteing design a dreamlike virtual reality experience of his creative process, called *My City of Lights*, which was available on a VR headset at the flagship Balmain Milan boutique. The 360 virtual experience was also extended in a groundbreaking partnership with Oculus VR Facebook, described by Rousteing as a means to "bridge the gap between fashion and technology".

Rousteing has more recently embraced TikTok too and in 2020 started posting home videos of him designing clothes alongside a clone version of himself observing his every move. It was a slightly unsettling sight, which Liana Satenstein in *Vogue* observed, "reminded me strangely of the Sims".

For Rousteing, his willingness to embrace social media and the latest technology isn't just about selling clothes or even self-promotion; it is about democracy, as he explained to the *Evening Standard*:

"I never believed that luxury should go against democracy, I feel like sometimes people think that luxury should just be untouchable, exclusive. I think we need to open to the world and that's always what I try to do."

OPPOSITE Cara Delevingne, the poster girl for the collaboration between Balmain and Puma, pictured at the launch wearing a logo gold-trimmed crop top and gold-zip joggers. The joint campaign focused on the empowering sport of boxing.

FRIENDS
AND
MUSES

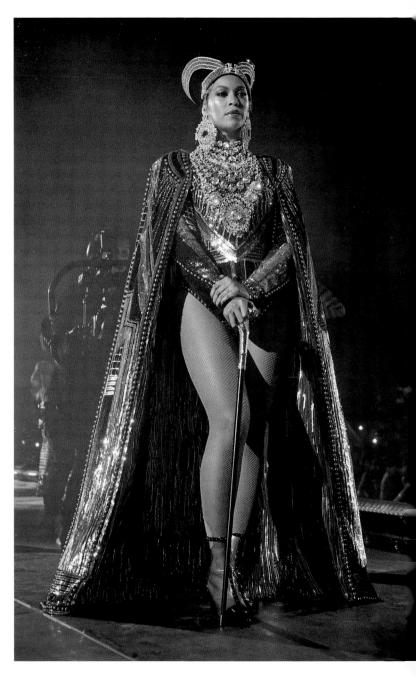

CELEBRITY COLLABORATIONS

Most old-school luxury fashion houses, traditionally worn by royalty and the socially elite, today rely on new-generation celebrities to endorse their clothes, a necessity that Rousteing has been honest about.

He has also expressed the wish that luxury fashion be more all-inclusive, explaining to Jess Cartner-Morley in the *Guardian* in 2016 that brands like Balmain can be aspirational without being snobbishly exclusive:

"Some people feel luxury shouldn't look like what the masses like. They feel it should be more elitist… Balmain is pop, but it is a luxury brand as well."

Since Rousteing cast Rihanna in her first luxury fashion campaign in 2013, followed by Kim Kardashian and Kanye West a year later, it has become the celebrities who are the generals of the Balmain Army. In particular, the extended Kardashian clan has been key to the success of Balmain. As

OPPOSITE One of Olivier Rousteing's greatest triumphs was the design of Beyoncé's iconic wardrobe for her headline performance at the 2018 Coachella music festival. The opening outfit, inspired by Queen Nefertiti, was comprised of a heavily embellished gold and black bodysuit with matching cape and hat along with a black cape bearing a crystal-embroidered motif of the Egyptian queen with an inscription of Beyoncé's name.

RIGHT Rihanna was one of Rousteing's earliest celebrity friends and muses. Shown here wearing a khaki leather outfit from Balmain's Autumn/Winter 2014 collection.

OPPOSITE Olivier Rousteing has said that out of all his muses it is Kendall Jenner who most embodies the spirit of Balmain. Jenner epitomizes the Balmain look in this image from the Autumn/Winter 2017 show dressed in a patchwork fitted brown snakeskin outfit with a studded fine mesh panel and sleeve, a fringed skirt and snakeskin legging boots.

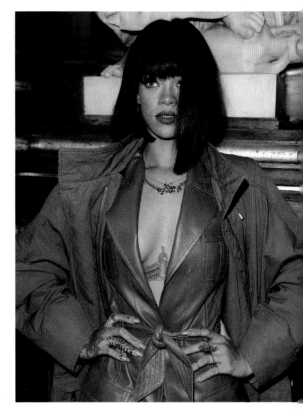

Cartner-Morley said of their relationship:

"Olivier Rousteing is to the Kardashians what Sandro Botticelli was to the Medici Family."

In other words, the influential family who have semi-adopted and sealed the reputation of a young creative. Matriarch Kris Jenner even said, seated front row at Balmain's Autumn/Winter 2019 show: "Olivier is like one of my kids."

Rousteing, who has been responsible for the transformation of Kim Kardashian's wardrobe since the pair met at the Met

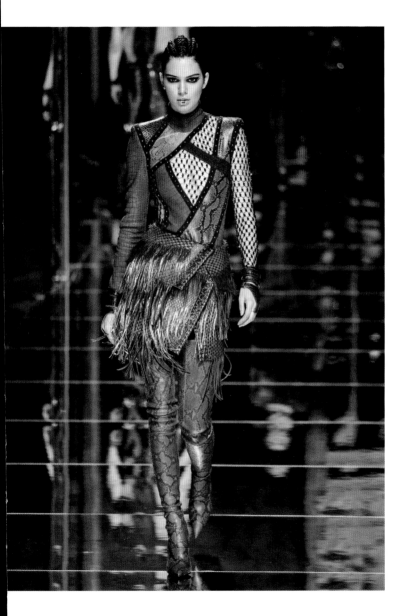

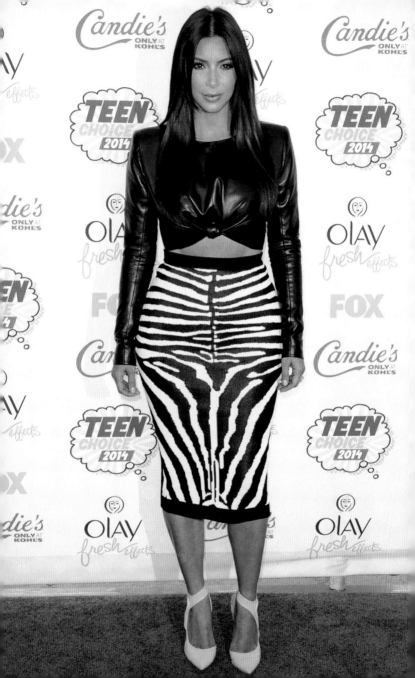

Gala in 2013, famously called the reality star the ultimate modern muse, telling CNN in 2017:

"I choose muses that are actually really different and modern – I chose them because they are contemporary, they are part of this new world."

Kardashian also ticked Rousteing's all-important diversity boxes, including his rebellion against fashion's obsession with skinny models. He even paid homage to her style in his Autumn/ Winter 2016 collection, sending out models in her preferred icy colour palette, their hips padded into an ultra-curvaceous silhouette. Rousteing opined in *Harper's Bazaar:*

"I also think she's pushing boundaries when it comes to the female form. I love dressing her, she's a different body type to the models on my catwalk – she's part of my world."

Kim Kardashian feels similarly close to Rousteing. As well as recalling how she and the designer hit it off, both personally

LEFT Model Jourdan Dunn in a typically glitzy, striped sequinned minidress at a dinner, hosted by Rousteing, for the opening of the new London flagship store in 2015.

and aesthetically, the reality star explained in an interview with *Vogue* in 2021 why she loved his Balmain look so much:

"He's really fun and flashy, and he can go from sculptural to really casual while always making you feel glamorous. Each of the pieces feels over-the-top in the best way."

Supermodel Kendall Jenner, however, is the clan member who Rousteing has said he feels closest to, and who most embodies the spirit of Balmain. Interviewed in *Harper's Bazaar*, the designer praised Jenner, who was the face of the luxury label's collaboration with H&M, when the collection launched in 2015:

"The campaign has to reflect the Balmain Army and, for me, she is the most important. She also has an amazing soul and is so supportive. It is important for me to have my friends around me to support every project that I do. She's just

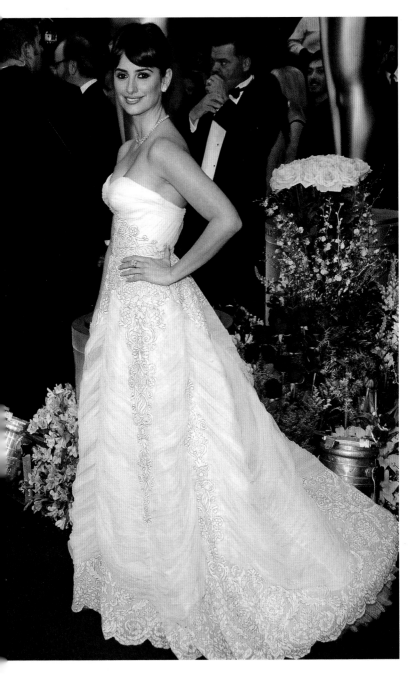

amazing and inspires an entire generation. I love that she's global, and loves music, dancing, she's the Balmain girl."

Music has long been a huge inspiration to Rousteing, and several of his closest friends and muses come from the world of pop. Rihanna is one such friend and inspiration, and in 2018 Beyoncé turned to Rousteing to design her wardrobe for her appearance at the cult music festival Coachella. As the first Black woman to headline at the festival, the pressure was immense, but Beyoncé's performance, and her incredible look, made such an impact that in the hours and days immediately following her set, Coachella was nicknamed Beychella.

This was Rousteing's second time working with Beyoncé – he had previously designed for her Formation tour – but this time Balmain was dressing the whole crew, from dancers to band members, a mammoth design task for which Rousteing and his team had three months to prepare. Not only did the outfits have to look stunning but they needed to be practical enough to move freely.

Rousteing worked incredibly closely with Beyoncé, who had a strong vision of what she wanted, coming up with outfits that combined the technical artistry of couture, the glitz and glamour required by such a high-octane performance, and a more relaxed nod to street fashion.

The collection spanned a wide range of influences, including an Egyptian theme, and Beyoncé's opening outfit was inspired by Queen Nefertiti. A heavily embellished gold and black bodysuit with matching cape and hat, the ensemble took two months to make, and was magnificent. The black cape even had a crystal-embroidered motif of the Egyptian queen with Beyoncé's name inscribed on it. As Rousteing told *Dazed* magazine:

"I wanted her to look like a goddess, so every detail had to feel timeless. This is the outfit that people will remember from

ABOVE The Met Gala has been called "fashion's biggest night out" by *Vogue* magazine and Balmain is renowned for going all out to dress celebrities for the themed event. Here Rousteing is photographed with Natasha Poly, Jennifer Lopez and Julia Stegner for the 2018 event themed "Heavenly Bodies: Fashion and the Catholic Imagination".

this generation, to the next ten generations; people will open books and see that outfit."

The Beyoncé Coachella wardrobe subsequently inspired a spin-off collaborative capsule collection from Balmain, the proceeds of which were to go to charity. This willingness to use a fashion success story for the greater good is typical of both Rousteing and Beyoncé. As Rousteing told *Vogue* in 2018 when the collaboration was announced:

"Beyoncé … is so strong and has such a great point of view. She's about feminism, empowering women, and the idea of bringing that collaboration where we can share the same ideas, the same vision of music, the same vision of fashion, the same vision of what is going on in the world, it's more than just clothes. It's a strong message, and I'm really proud to be a part of that."

Rousteing's success with Beyoncé's Coachella outfits has led to his collaboration with various other artists including Bjork, for whom he adapted silhouettes from his 2019 couture collection to create a series of sculptural pieces for the outlandish singer.

Increasingly Balmain has become the go-to label for celebrities wanting to make a statement, and there is no place where an outfit is more heavily scrutinized than at the Met Gala. Each year, in line with the fashion-focused charity event's annual theme, Balmain creates couture garments for its invited guests to wear.

For the 2016 Met Gala, the Kardashians and Jenners were unanimously loyal to Balmain, with Rousteing taking the Costume Institute's theme: "Manus × Machina: Fashion in an Age of Technology" and interpreting it as a series of "sexy, blingy robot" gowns as Kim Kardashian described them.

The 2016 line-up also included Kylie Jenner who shimmered in a body-conscious fringed silver cutaway Balmain gown for her

LEFT Kylie Jenner wore this figure-hugging silver dress, made from strips of crystals to her debut 2016 Met Gala, the theme of which was "Manus × Machina: Fashion in An Age of Technology".

first time at the event. Other famous names who wore Balmain included Cindy Crawford, Jourdan Dunn, Doutzen Kroes, Corey Gamble, Alessandra Ambrosio, Joan Smalls, Sean O'Pry and Tyga.

For the 2018 Met Gala Balmain sponsored a table of Balmain Army stalwarts comprised of Jennifer Lopez, Juliette Binoche, Natalia Vodianova, Natasha Poly, Julia Stegner, Alex Rodriguez and Trevor Noah. This time Rousteing designed one-off gowns and tuxedos for the event, complete with fashion illustrations that were later auctioned off, the proceeds going to (RED) the AIDS charity founded by Bono and Bobby Shriver.

Inevitably Balmain hasn't always been immune to some raised eyebrows over its Met Gala looks. In 2019, Liza Koshy wore a hybrid silver latticework gown and architectural pink feathered wrap-around structure, which was compared to a fluffy eiderdown by some. To be fair, the event's theme that year was "Camp: Notes on Fashion".

The glittering appeal of Balmain to the rich and famous doesn't seem to be dimming, and Olivier Rousteing continues to include a diverse range of models and celebrities, both young and experienced, in both his fashion shows and advertising. In 2022, Rousteing's tenth anniversary as designer-in-chief for Balmain featured legendary 1990s supermodels Naomi Campbell, Milla Jovovich, Karen Elson, Lara Stone, Natalia Vodianova, and Carla Bruni alongside their modern-day counterparts Adut Akech, Precious Lee, Imaan Hammam, and Cindy Bruna.

Since Rousteing reintroduced Balmain to the haute couture schedule in 2019, some of his more experimental looks have been adopted by celebrities. An eccentric gown from the collection, worn by Katy Perry to the Grammy Awards in 2019, had a silver bustier teamed with a pink skirt created from layers of frothy tulle, leading some critics to compare the singer to a toilet-roll holder or paint roller.

OPPOSITE Kenyan-Mexican actress Lupita Nyong'o, wore a long, halterneck multicoloured knit dress from Balmain's Resort 2017 collection to the premier of her film *Queen of Katwe* in 2016.

LEFT With his increased focus on menswear, Olivier Rousteing has attracted celebrities such as racing driver Lewis Hamilton, spotted attending the Autumn/Winter 2017 menswear show wearing Balmain's glitzy, heavily sequinned version of a denim jacket.

OPPOSITE Another sports celebrity who is a big fan of Balmain is Brazilian footballer Neymar, pictured here at the menswear Autumn/Winter 2020 show wearing a silver patchwork jacket which gives a mirrored effect.

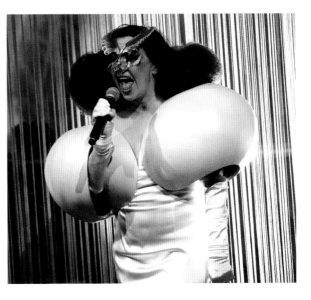

Right now, Rousteing is riding the crest of a wave and is not averse to using his success to lure celebrities to appear in his shows. The most memorable appearance lately must surely be that of Cher for his Spring/Summer 2023 collection. The iconic performer appeared on a screen as the show opened, setting the scene with the words: "All of us invent ourselves – some of us just have more imagination than others."

Onlookers assumed that Cher's pre-recorded segment was enough of a statement, but Rousteing's real coup was getting the 76-year-old, looking incredible in a skintight metallic jumpsuit with Balmain's signature pointed shoulders, to appear in person for the show's finale. As the audience stood and cheered, Cher walked down the catwalk alongside Rousteing to the backing sounds of her 1999 hit "Strong Enough". Just like with Beyoncé, Rousteing's commitment to female empowerment through fashion was clear.

INDEX

Numbers in italics refer to pages with captions.

Academy Awards *144*
Accessories 43, 51, *114*
Adulte Adulte 112
Akech, Adut 151
Alt, Emmanuelle 82
Ambrosio, Alessandra 123, 151
And God Created Woman 62
ASAP Ferg *120*
ASAP Rocky *120*

bags *115*
Baker, Carroll *53*
Baker, Josephine *43*, 57, *58*
Balenciaga 33
ballgowns *45*, 58, *82*
Balmain, Pierre 7, *7*, *10*, *15*, *42*
 birth 15
 death 9, 37, 71
 education 16
 father's death 15
 financing 30
 first show 25, *25*, 26, 29, 33
 heritage 90, 93, 107, 108
 "Jolie Madame" look 33, *35*, 91
 Légion d'Honneur 36
 My Years and Seasons 25
 overlicensing 36

perfume 33
salon *25*
Bardot, Brigitte 8–9, *45*, 46, 58, 62, *62*
Basna of Jordan, Queen 50
Basques *16*, *132*
Beaton, Cecil 29, 41
Beckham, David 120
Beleiu, Dan 114
Belts *31*, *34*, *45*, 61, 65, *67*, *73*, *93*, *94*, 95, 96, *97*, 98, *104*, 107, *107*, *110*
Bérard, Christian 41
Bergman, Ingrid 46
Beyoncé 7, 67, 134, *139*, 147, 148, 155
Binoche, Juliette 151
Bjork 148, *155*
Black Magic 58
Bodice 29, 33, 34, 46, 53, 58, *61*, 62, *67*, *75*, *76*, *82*, *108*
bodysuit *139*, 147
Bono 151
boots *10*, *84*, *103*, *109*, *114*, *140*
Brant Jr, Peter 123
Bruna, Cindy 151
Bruni, Carla *71*, 151
Business of Fashion 41, 90

Campbell, Naomi *71*, 151
Cañadas, Esther *111*

capes 25, 33, 35, *43*, 46, *53*, 58, *75*, *76*, 103, *104*, *139*, 147
Carpetbaggers, The 53
Cartner-Morley, Jacob 139, 140
casual look *124*
catsuit 82, *118*
Cavalli, Roberto 90
Cellier, Germain 37
Chambre de Syndicale de la Haute Couture 20
Chanel 96, 98
Charisse, Cyd 65, *67*
Chenoune, Farid 29
Cher 155, *155*
Christensen, Helena *71*, *110*, *111*
CNN 143
Coachella 132, *139*, 147, 148
coats 16, *26*, *31*, *33*, *34*, *36*, 46, *46*, 53, 72, *73*, *103*, 115, *116*
Cohn, Nudie 93
collections
 1945 *15*, 16, *16*, 20, 25, *25*, 29, 33
 1947 *27*, 33
 1952 33
 1958 Autumn/Winter *34*
 1962 Spring/Summer *36*
 1994 Autumn/Winter *71*
 1995 Autumn/Winter *73*, *75*

1999 Autumn *75*

2002 Spring/Summer *76*

2006 Autumn/Winter 77

2009 Spring/Summer *78*, *81*

2010 Autumn/Winter *84*

2011 Autumn/Winter 10, 82

2012 Spring/Summer 93

2012 Autumn/Winter 93, *93*

2013 Spring/Summer *10*, 93, *94*, *95*

2013 Autumn/Winter 94–5, *96*

2014 Spring/Summer 96

2014 Autumn/Winter 98, *140*

2015 Spring/Summer *98*,

2015 Autumn/Winter *98*

2016 Autumn/Winter 103, *103*, 143

2017 Spring/Summer 103, *104*

2017 Autumn/Winter *90*, 107, *107*, *109*, *140*, *152*

2018 Spring/Summer 107

2018 Autumn/Winter 107

2019 Spring/Summer *108*, 114

2019 Autumn/Winter *114*, *123*, 140

2020 Autumn/Winter *110*, 115, *124*, *152*

2021 Spring/Summer *112*

2022 Autumn/Winter 116

2023 Spring/Summer 119, 131, *155*

Cooper, Lady Diana 46

COVID 116

Crawford, Cindy 151

Cruz, Penélope *144*

crystals 50, 93, *93*, 95, *95*, 97, *97*, 98, *98*

 Swarovski 10, 58, 79, 103, 111, 116

Dazed magazine 147

de la Renta, Oscar 9, *71*, 72, *75*, *76*, 108

Decarnin, Christophe 10, 77, 78, *78*, 79, *79*, 81, *81*, 82, *82*, 85, 89, 90, 120

Deep Blue Sea, The 61, 65

Delevingne, Cara 114, 128, *134*

Dietrich, Marlene 43, 58

Dior, Christian 7, 19, 20, *20*, *16*, 29, 33, 35, 82, 85, 96, 108

dresses 9, *16*, 26, *31*, *33*, *41*, *43*, *45*, 46, 50, *50*, *62*, 65, *67*, *73*, *75*, *90*, 98, *104*, *147*, *155*

Duffour, Gilles 76

Dunn, Jourdan *90*, 98, *124*, 128, *143*, 151

Elson, Karen 151

Evening Standard, the 133, 134

Fabiola of Belgium, Queen 50

Fairchild, John 35–6

Ferrer, Mel 9, *45*, 46

Fonda, Jane *67*

Ford, Tom 79

fragrances 37

 Elysées 37

 Jolie Madame 37

 Vert Vert 37

Galleries Parisiennes 15

Galliano, John 82

Gamble, Corey 151

Gaultier, Jean Paul 134

Givenchy 35, 46

gowns 27, *29*, 34, *46*, *53*, 58, *58*, *61*, 62, 65, *75*, *76*, *98*, *144*, 149, *149*

Grailed 78, 82

Grammy Awards 151

Grès, Madame 26

Grey, Nadia *57*

Guardian, the 139

Gucci 79

Hadid, Gigi *124*, 133

Hamilton, Lewis *120*, *152*

Hammam, Imaan 151

Happy New Year 65

Harder They Fall, The 67, 134

Harlow, Winnie *90*

Harper's Bazaar 143, 144

hats 9, 53, 58, *76*, *116*, *118*, *139*, 147,

Hengel, Julia *111*

Hepburn, Audrey 9, *45*, 46, 58

Hepburn, Katharine 8, *42*, 46, 58

Her Bridal Night 62, *62*

Hilton, Conrad *41*

Hivelin, Alain 77, 89, 90

Hollywood Reporter, The 113

House of Balmain

 Apple Beats 131

 atmosphere 42,

 Barbie 131

 cosmetics 131

 exclusivity 139

 foundation 7

H&M collaboration *124*,
128, *128*, *131*, 144
logo 112–3, *112*, 114, *115*
London store *143*
menswear 120–23, *120*,
123, *131*
Milan boutique 134
monogram 112–3
New York store 33
Pokémon 131
Puma collaboration 128
rebranding 112, *112*
Rossignol collaboration 131
transformation *8*, 10
virtual models 133–4
Victoria's Secret
collaboration 128, *132*
In Case of Adversity 65
Instagram 10, 113, 116, 133,
134
Irene of the Netherlands,
Princess 46
It isn't All Mink 42

jackets 10, *41*, 81, *90*, 94, 96,
96, 98, *104*, 107, *108*,
109, *110*, 116, *118*, *152*,
Jackson, Janet 114
Janet 114
Jeans 10, 79, 81, 89, 120, *124*
Jenner family 140, 149
Kendall *124*, 128, *128*, 133,
140, 144
Kris 123, 140
Kylie 131, 149, *149*
John, Elton 93
"Jolie Madame" look 33,
35, 91
Jovovich, Milla 151

jumpsuits 62, *94*, *98*, 111,
121, 155
Kardashian family 7, 140, 149
Kardashian, Kim 103, *103*,
128, 133, 139, 140,
143–4, *143*, 149
Kebede, Liya *111*
kimono 27
knits 65, *90*, 103, *104*, 111,
131, *147*, *151*,
knitwear 93, 116,
Koshy, Liza 151
Kroes, Doutzen 151

L'Oreal Paris 131
Lacroix, Christian 94
Lee, Precious 151
Leigh, Vivien 46, *46*, *61*, 65
Leitch, Luke 107
Lelong, Lucien *16*, 19, *19*,
20, 29
Lima, Adriana *134*
Lopez, Jennifer *148*, 151
Loren, Sophia 46, 58
Love Cage, The 65, *67*

Maquieira, Marcelo 81
Margaret, Princess *53*
Margaretha of Luxembourg,
Princess 50
Margot 134
Maria-Teresa of Luxembourg,
Princess 50
Marie-Chantal of Greece,
Crown Princess 72
Mayhoola 103, *104*
McDowell, Colin 16, 41
Men's Fashion Week 120
Mercier, Laurent 76

Met Gala 140, 143, *148*, 149
Metropolitan Museum of
Art 34
Millionairess, The 58
Minaj, Nicki *90*
minidress *81*, *82*, *93*, *95*
miniskirt *10*, *84*, 103, *103*,
132
Miss Balmain 37
Molyneux, Edward 16, 30
Monde, Le 46
Montez, Maria *25*
Mortensen, Erik 71
Moss, Kate 81
MTV Music Video Awards
147
muff *9*
My Body 144
My Years and Seasons 25,

negligée *62*
Neiman Marcus Fashion
Award 33
Netflix 67, 89, 113, 134
New Look hourglass silhouette
7
New York Daily News 51
New York Times, the 81, 82, 12,
Neymar *152*
Noah, Trevor 151
Nyong'o, Lupita *151*

O'Pry, Sean 151
Olivier, Laurence *46*
Out magazine 90

Paco Rabanne 77
Palmer, Lili 46
Paris Opera, The 67

Parisienne, La 65, *65*
perfume 33
Perry, Katy 151
Petit Café, Le 57
petticoats 29, 62, *75*
Phelps, Nicole 98
Pierre, Hervé 71
Piguet, Robert 16
Poly, Natasha *148*, 151
Presley, Elvis 93

Queen of Katwe 151

Ratajkowsi, Emily *133*
Revlon 37
Ribeiro, Caroline *111*
Rihanna 81, 98, *133*, 139, *140*, 147
Ritchie, Sofia *120*
Rodriguez, Alex 151
Roitfeld, Carine 10, 61
Roitfeld, Julia 61
Roman Spring of Mrs. Stone, The 61, 65
Rousteing, Olivier 7, *8*, 10, *10*, 67, 72, *75*, *76*, 82, 85, 89–134, *89*, *90*, 139, *139*, 140, *140*, 143, *143*, 144, *144*, 147–8, *148*, 151, *151*, *153*, 155, *155*
Royal Film Performance *45*

Saint Laurent, Yves 85, 115
Saint-Jean-de Maurienne 15
Sampaio, Sara *90*
Satenstein, Liana 134
Shaw, Debra *75*
Shriver, Bobby 151
Shudu 134

silhouettes 7, *10*, *16*, 29, 31, 33, *34*, *45*, 46, 53, 72, *79*, 91, 93, *94*, 95, 98, 103, 107, 111, 123, *124*, 131, 143, 148
Sirikit of Thailand, Queen 9, 33, 50, *50*, 51, *51*, 53
skirts 16, 20, *26*, 29, 33, 34, *37*, *45*, 46, *61*, 62, 65, *67*, *75*, 98, *107*, 140, *143*, *144*, 151
Skriver, Josephine *134*
Smalls, Joan 151
Social media 133–4
Spanier, Ginette 42, 43
Steel, Danielle 72
Stegner, Julia *148*, 151
Stein, Gertrude 16, 19, *19*, 27, 29, 41,
Steinfeld, Hailee *147*
Stone, Lara 151
Stranger Things 134
Strijd, Romee *134*
"Strong Enough" 155
suits 16, 34, *37*, 43, *46*, 53, *61*, *75*, 93, 115

T-shirts 7, *10*, *79*, 81, 107, 120
TargetStyle *144*
Taylor, Elizabeth 8, *41*, 46
Teen Choice Awards *143*
Thai silk 53
TikTok 113, 116, 134
Toklas, Alice B. 16, 19, *19*, 27, 29, 41
Tookes, Jasmine *134*
Top Shop 81
tops *10*, 53, 85, *94*, *97*, *103*, *107*, 116, *128*, *134*, *143*,

trouser suit *75*,
trousers 79, 93, *96*, 110, 116, *124*
tuxedo *124*, *128*, 151
Two Weeks in Another Town 65, *67*
Tyga 151

Valentino 111
velvet *31*, *43*, 46, *73*, *84*, 93, 123, *128*
Versace 94
Victoria and Albert Museum 46
Vittel *35*
Vodianova, Natalia 151
Vogue 16, 29, 33, 41, 71, 76, 82, 93, 98, 107, 108, 111, 115, 134, 144, *144*, 148, *148*
Vogue, American 33
Vogue British 119
Vogue Paris 10, 81, 82
von Fürstenberg, Alexandra 72
Vreeland, Diana 33

Wall Street Journal, the 133
Wasson, Erin *111*
West, David 120
West, Kanye 139
Wilson, Cameron-James 134
Windsor, Duchess of 41
Women's Wear Daily 8, 35–6, 72
Wonder Boy 89, 113

Zara 81
Zhi 134

CREDITS

The publishers would like to thank the following sources for their kind permission to reproduce the pictures in this book.

Alamy: Abaca Press 141; /AFF 142, 145; /Collection Christophel 66; /Everett Collection Inc 62; /Kathy Hutchins 134; /Mascheter Movie Archive 61; /Doug Peters 146; /PictureLux/The Hollywood Archive 67; /Zuma Press, Inc 64; /WENN Rights Ltd 129

Getty Images: Neilson Barnard/Getty Images for Target 144; /David M. Benett/Getty Images for Balmain 143; /Bettmann 18, 32, 36, 37; /Edward Berthelot 114, 115; /Bettmann/Corbis 26; /Victor Boyko 91, 120; /Giancarlo Botti/Gamma-Rapho 48-49; /E.C. Bowen/The Sydney Morning Herald/Fairfax Media 27; /Bill Brandt/Picture Post/Hulton Archive 30; /Larry Busacca/Getty Images for Coachella 138; /Stephane Cardinale/Corbis 154; /Walter Carone/Paris Match 40, 56; /Dominique Charriau/WireImage 108, 110, 111; /John Chillingworth/Picture Post/Hulton Archive 31; /Corbis 21; /Antonio de Moraes Barros Filho/WireImage 92; /Michel Dufour/WireImage 140; /Santiago Felipe 155; /Gamma-Keystone 51; /Jack Garofalo/Paris Match 47; /Giovanni Giannoni/Penske Media 75, 84; /Francois Guillot/AFP 80,

85; /Ernst Haas 44; /Hulton-Deutsch Collection/Corbis 52, 53; /Nicholas Hunt/Getty Images for H&M 126-127; /Dimitrios Kambouris 149; /Keystone-France/Gamma-Keystone 14, 17, 19, 24, 35; /Kurt Krieger/Corbis 88; /Jacques Lange/Paris Match 77; /Reg Lancaster/Express 6; /Pascal Le Segretain 8, 94, 99, 100-101, 102, 104, 112, 121; /Mondadori 9; /Jean-Pierre Muller/AFP 76; /Mdu Ndzingi/Sowetan/Gallo Images 150; /Bertrand Rindoff Petroff 152; /Jacopo Raule 153; /Rolls Press/Popperfoto 34; /Seven Arts Productions/Warner Bros. /Daniel Simon/Gamma-Rapho 70, 73, 74; /Kristy Sparow 124, 125; /Sunset Boulevard/Corbis 60; /STF/AFP 42; /Kevin Tachman/Getty Images for Vogue 148; /Taylor Hill/FilmMagic 132; /Etienne Tordoir/WireImage 130; /Ullstein Bild 35, 59; /Pierre Verdy/AFP 83; /Victor Virgile/Gamma-Rapho 11, 95, 96, 97, 105, 106, 109, 122; /Peter White 117, 118

Shutterstock: AP 28, 45; /Henry Clarke/Condé Nast 50; /George Elam/Daily Mail 63

Every effort has been made to acknowledge correctly and contact the source and/or copyright holder of each picture. Welbeck Publishing apologizes for any unintentional errors or omissions, which will be corrected in future editions of this book.